MW00333732

MINNESOTA MYSTERIES

A HISTORY OF

UNEXPLAINED WONDERS,
ECCENTRIC CHARACTERS,
PREPOSTEROUS CLAIMS BAFFLING OCCURRENCES

in the Land of
TEN THOUSAND LAKES

BEN WELTER

THE
History
PRESS

Published by The History Press
Charleston, SC 29403
www.historypress.net

First published 2013

ISBN 978-1-5402-0967-2

Library of Congress Cataloging-in-Publication Data

Welter, Ben.
Minnesota mysteries : a history of unexplained wonders, eccentric characters, preposterous claims and baffling occurrences in the land of 10,000 lakes / Ben Welter.
pages cm
ISBN 978-1-5402-0967-2
1. Minnesota--History--Anecdotes. 2. Minnesota--Biography--Anecdotes. 3. Curiosities and wonders--Minnesota--Anecdotes. I. Title.
F606.6.W46 2013
977.6--dc23
2013043029

Contents

Contents

Introduction

The first edition of the *Minneapolis Tribune* hit the streets in May 1867. Virtually every page of every issue of the *Tribune* and its descendants is preserved on microfilm stored in steel cabinets at the *Star Tribune* office in downtown Minneapolis. During dinner breaks, I head to the newsroom library, fish out one of the hundreds of rolls, thread it into a digital reader and take a look back in time. The big stories are all there of course: World War I, Black Friday, the New Deal, World War II and more. But like many readers, I gravitate toward the "Hey, Martha!" stories, the unusual pieces that grab your attention at the breakfast table, the nuggets you read aloud to your spouse. These stories find new life in my blog, "Yesterday's News" (www.startribune.com/yesterday). Since 2005, I've posted five hundred stories and more than one thousand photos. Fresh interviews, background research and reader recollections flesh out many of the posts.

Minnesota Mysteries, a collection of strange and baffling stories from the past 140 years, is the second book based on my blog. These newspaper accounts are preserved in their original form, along with photos from the archives of the Minnesota Historical Society, Hennepin County Library Special Collections, Library of Congress, *Grand Rapids Herald-Review*, Excelsior-Lake Minnetonka Historical Society, St. John's Abbey, St. Scholastica Monastery and the *Star Tribune*.

The lion's share of the credit for this volume goes to the skilled and enterprising (and mostly anonymous) reporters and photographers who originally covered these stories. Credit also goes to the sharp-eyed editors

on the *Star Tribune* copy desk—most notably Catherine Preus, Holly Collier Willmarth and Pam Huey—who checked my raw blog posts. They caught countless errors and offered excellent suggestions on titles, captions and research. Family members were also a massive help: my wife, Mona, scoured the Web for images; my stepson, Jim McCarron, handled genealogical research; and my son, Matthias, proofed the final manuscript.

I hope you enjoy these voices from Minnesota's past.

A Woman in Man's Clothes

SEPTEMBER 13, 1883, DAILY MINNESOTA TRIBUNE

In a single 343-word paragraph, the Tribune *attempted to unravel the mystery behind a street fracas involving a "falsely costumed woman" and a one-legged railroad man. "East side" refers to the east bank of the Mississippi River, opposite downtown Minneapolis.*

A WOMAN IN MAN'S CLOTHES
THE RESULTS OF A STREET FRACAS LAST EVENING BRING TO THE SURFACE A QUEER CHARACTER—WHO IS SHE?

Quite an excitement was occasioned on the East side early last evening, when two of the principals in a street fracas were arrested and one of them was found to be a woman in male attire. It appears that as A.J. Balden, a railroader who has only one leg, was passing the falsely costumed woman and three friends the woman made a remark which reflected upon the cripple, who turned around and commenced an attack upon them. The noise attracted the police, but all but the woman and the railroader escaped. Subsequently a young man was arrested who is believed to have been one of the companions of the woman. The woman is of intelligent appearance and says she resides at 410 Main street south. The party consisted, the woman says, of herself and lover and the young man arrested and his sweetheart. She claims it was nothing but a foolish freak, with results that "will teach me a lesson that I will long remember." Capt. Chase, who made the arrest, however, regards with suspicion the queer "freak." Early in the evening the four persons

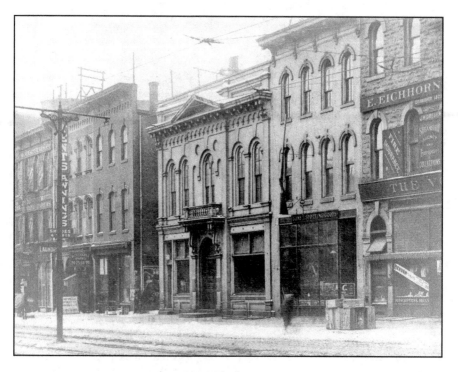

Washington Avenue's Centre Block near Hennepin Avenue in the 1890s or early 1900s. *Courtesy Hennepin County Library Special Collections.*

were seen at the Velveteen gardens on Washington avenue south. An observer was impressed with the idea that the parties were not sexed as their attire would lead one to believe, and concluded to "shadow" them, supposing them up to some crooked business. He continued his shadowing until they were arrested, as mentioned above. In these times such conduct is apt to create suspicion, and this matter will no doubt be thoroughly investigated. Late in the evening a young man presented himself at the lockup and asked a person standing near if a lady attired in men's clothing had been arrested. He was answered in the affirmative and upon being told that seven or eight officers were then engaged in searching for the remaining members of the mysterious quartette, the questioner made short work of getting though the alley way. He was no doubt one of the four and may join his companions in durance before the morning dawns.

The *Minnesota Tribune*'s front page of September 13, 1883, was a text-heavy, photo-free and ad-laden affair.. The story of the one-legged railroad man and the woman in male attire landed on an inside page.

The St. Paul Daily Globe *offered this follow-up the next day, under the heading,* "MINNEAPOLIS NEWS":

Mrs. Jennie Hilton, together with her festive companion, Barney Bredron, were arraigned before Judge Mahoney yesterday morning, charged with disorderly conduct. Mrs. Hilton is one of the women who masqueraded in men's attire on Wednesday night. The two women with Barney Bredron and Nels Whitmarsh started from their house, 410 South Main street, East side, crossed the lower bridge, up Washington avenue to the Velveteen gardens, where they took a glass of beer each. Thence they went across the suspension bridge and Jennie and Barney were arrested by Captain Chase. They each paid fines in $5 and costs. Jennie says she will never more play masculine roles.

"Little Georgia Magnet" Astounds Hudson

OCTOBER 15, 1890, MINNEAPOLIS TRIBUNE

Inspired by Lulu Hurst, the "Georgia Wonder," Dixie Annie Haygood of Milledgeville, Georgia, developed a vaudeville act that featured feats of strength that seemed to defy the laws of physics. With the touch of her hand, the petite young woman could lift a group of three men perched on a chair. And no amount of effort by four men could lift her off the floor as she stood on one foot. Under the stage name Annie Abbott, she performed at the opera house in Milledgeville and in other nearby towns.

In 1886, following her husband's death, the "Little Georgia Magnet" took her act—and her three children—on the road, performing in cities across the northern United States. In one of her first appearances in the Upper Midwest, she faced a stern test. A few sober citizens of Hudson, Wisconsin, were selected from the audience to test her "strange" powers. A physician's eyewitness account appeared a few days later in the Tribune:

A WONDERFUL WOMAN
MRS. ABBOTT WIPES UP THE FLOOR WITH THE PRESS, THE COURT AND THE CLERGY.

HUDSON, Wis., Oct. 11.—(Special)—Much has been said through the press recently about Mrs. Abbott's strange "power" over men; how she would resist the combined strength of several big strong men; that she could lift eight or ten men; and six men could not lift her, and many other apparently absurd and ridiculous things that this woman could do. Our people took but little stock in the reports until some of our own reputable citizens saw her exhibition a few evenings since at Chippewa Falls, and efforts were instituted to have her visit Hudson, which resulted in her appearance Friday evening.

In July 1891, Annie Abbott appeared in Minneapolis at the Grand Opera House near Sixth Street and Nicollet Avenue. An ad in the *Tribune* promised "a marvelous performance…given in the full view of the audience in the bright glare of gas light."

She is a delicate little creature, a perfect type of Southern beauty, with sparkling black eyes and most pleasant face. When she reached the opera house, a committee was selected from the audience to supervise the tests and investigate the "wonder." Among those selected were George C. Hough, District Attorney S.N. Hawkins, George D. Cline, of the Republican. All phases of avocation were represented.

The fun began. She literally wiped up the floor with the court, seriously interfered with the freedom of the press and blocked the church. The whole gang wasn't a bagatelle for her. It was the most wonderful and utterly inexplicable exhibition—a genuine phenomenon—ever witnessed in this country. People may scoff and turn up their nose at the supernatural or, unnatural forces, if you please. Hypnotism until recently had but few believers. Mesmerism and kindred phenomena were thought to be high-flown titles for "fraud" and "fake," but science has taken a hand and dispelled such ideas. It sounds a little "fishy" to state that she lifted two feet clear from the floor nine heavy men at one time, piled upon two heavy chairs, and as easily as the reader would this paper; in fact two gentlemen had their hands interposed between her hands and the chair, with no other contact when the entire mass came up, and those gentlemen assert that there was no more perceptible pressure against their hands than the weight of the hand.

Her muscles were examined during the tests and no sort of muscular action was found. What does it? The committee all tried singly to lift her, which the smallest man could do (she weighs not over 95) when she willed it, but when she preferred not, it remained not. Men tugged till their eyes bulged and they were red and blue in the face, but she remained smiling and as immovable as a block of buildings. Two, three, four, six and eight men together expended all their strength in vain to hoist her a particle. She picked men up by the ears, by the head, hoisted them on poles, by her fingers tumbled them around like paper balls.

Perhaps the most wonderful feat to the scientific was that in which a little boy, selected from the audience, was given in each hand the end of a silk handkerchief and she held the other ends slackly in her hands. Soon the boy began to tremble and shake violently for a moment till he became quiet when gentlemen were told to lift the boy. Lo, he was found to be loaded too, and was practically as heavy as Mrs. Abbott and could not be lifted. Sticks were laid across her open hands and could not be moved off them by three or four men. She stood upon one heel of her little No. 1 slipper and six men tried, by laying a pole across her breast, to push or pull her off her balance. They tugged till the stick broke, but not a fractional part of an inch did she give. Many other strange feats were performed.

A prominent gentleman who was on the committee said today: "To say there is any sort of trickery or mechanism about it, is to stultify your reason and insult the intelligence of those who made the tests."

Certainly there could be none. Every possible privilege and opportunity of investigation afforded the committee no sort of effort to conceal anything. In fact there were no doubting Thomases when she got through. Perhaps they were afraid to assert it if they thought so. A wag said today that both political parties were negotiating for Mrs. Abbott's services until after the election. It is safe to say she could carry an election. Never has anything occurred in this city that has created so much interest. One can hear nothing else discussed but Mrs. Abbott. She is surely a great phenomena. Possessed of a power to suspend gravitation seems most probable.

T.B. Williams, M.D.

A year later, under the headline, "No Longer a Wonder," the Tribune *revealed Annie Abbott's secret: "a skillful application of certain laws of physics," something anyone could do with a little practice. Here is the clearest example:*

To carry out the experiment depicted in figure 3 the two men are required to stand side by side, and the girl, facing them, places the palm of her hand on the side of the stick away from her, or on that side towards which the men are facing. She is also careful to place her hand as far from theirs as possible, thus gaining considerable leverage. She begins by moving her hand up and down on the stick, first with very slight, but with gradually increasing pressure, as if to make better contact. This diverts the stick from the perpendicular, and she tells them to hold it straight. As they endeavor to do this they are working to very great disadvantage, having little or no leverage whereas she has a foot or two. The strain on her is very slight, first, because the leverage is in her favor; and, second, because it is merely tensional in her arm. When she thinks she has sufficient pressure on her hand the order is given to the men to press down as hard as they can. They think they are exerting a tremendous vertical pressure, but the fact is their efforts are almost entirely consumed in keeping the stick vertical against her pull on the lower end. They know they are expending some energy in this way, but are confident that most of it is expended in vertical thrust. There is, of course, some of this, but their efforts to counteract her pull cause sufficient friction between her hand and the stick to support that thrust or its equivalent weight.

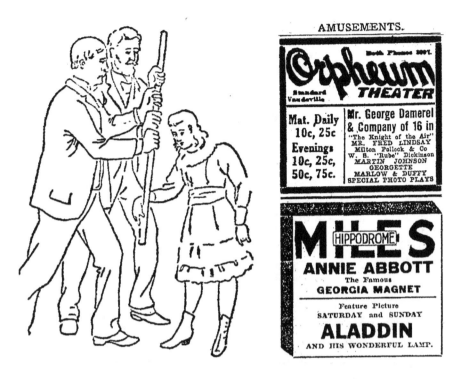

Left: On December 13, 1891, the *Tribune* explained how Abbott resisted the efforts of two men straining to prevent her from moving a stick. *From* Tribune *microfilm*.

Right: A performance by another "Annie Abbott" was among the amusements advertised in the *Tribune* in November 1913, years after the original Abbott, Dixie Annie Haygood, had stopped touring.

Despite the debunking in the Tribune *and other newspapers, Annie Abbott continued to astound audiences across the United States and Europe until about 1908. Her success inspired more than a few imitators; some even used her stage name. One likely imitator appeared in Twin Cities theaters as late as 1913. Dixie Annie Haygood, the original Annie Abbott, died two years later. She is buried at Milledgeville's Memory Hill Cemetery.*

Lost in a Minneapolis Sewer

DECEMBER 27, 1890, MINNEAPOLIS TRIBUNE

*I*t's a pity the annual Bulwer-Lytton Fiction Contest, which recognizes the best opening sentences to "the worst of all possible novels," has no category for historical nonfiction. This tortuous (and torturous) eighty-four-word lede from the Tribune would be a worthy contender.

LOST IN A SEWER

GUSTAV LARSON LOSES HIS BEARINGS AND WANDERS SEVERAL MILES TO RESCUE.

An employe of the city in the sewer department, named Gustav Larson, had an experience yesterday forenoon, which will likely serve him with excitement enough to last the remainder of his days, for the excitement in question was nothing less than a wandering trip, accidental, of course, through the labyrinthian depths of the city sewers, with no light to show the path and very little encouragement in the way of discovering a manhole, from which to escape from the none too pleasantly odored passageway.

About 10:30 in the morning, Larson, accompanied by two other members of the sewer gang, raised the covering from a manhole at Twenty-seventh street and Lyndale avenue, preparatory to making a descent into the sewer for an inspection and cleaning a jam, which seemed to exist. That particular portion of the sewer system is the main line for the Eighth ward residents and is 66 inches in height. The employe made the entrance to the sewer easily enough, his companions remaining above ground, according to agreement, in case of being needed to complete the job. The two, however,

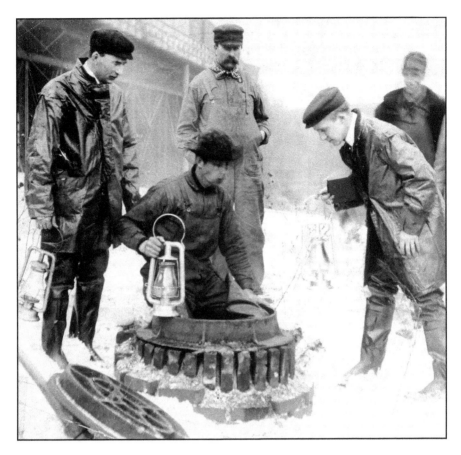

Toting lanterns to light the way, a Minneapolis sewer crew got down to business in about 1905. *Courtesy Minnesota Historical Society.*

seemed to think their assistance would not be called into requisition and proceeded to walk about the neighborhood, while the third member of the party, having completed his inspection, endeavored to find the manhole at which he entered the sewer, some distance from the scene of his task.

Alone and without a light, Larson lost his bearings, and his shouts for assistance brought no answer from the men above ground. Finally, becoming scared with his situation and realizing that he might have a serious job in escaping from the sewer, the man yelled frantically for help, meanwhile keeping a close lookout for a manhole in the top of the passage. There was no scarcity of these, but the height prevented an avenue from that direction. After roaming about for nearly two hours the man noticed that the

passageway was growing less in height and that he could probably manage to push the manhole covering from its place. An opportunity soon presented itself, and by the aid of the sewer walls, Larson reached terra firma, but completely exhausted from the poor ventilation and the excitement of his tramp, which was nearly three miles in length from the probable course he traveled. The escape was made at Fourth street and Cedar avenue, where the sewer is only 56 inches in height.

It was some time after reaching the open air until he could explain his experience, but in rather broken English, managed to declare that he had seen sufficient of the sewer work to satisfy any further desires in that direction.

How to Read Tea Leaves

AUGUST 2, 1896, MINNEAPOLIS TRIBUNE

I wouldn't be shocked to learn that one or two gifted tasseographers in the Twin Cities foresaw that this book would include a Minneapolis Tribune *piece on how to read tea leaves. But I doubt anyone could have predicted that I'd use "tasseographers," "tassologists" or "tasseomancers" in the introduction.*

YOUR FATE IN A TEA CUP
HOW SUMMER COTTAGES MAY SPEND RAINY DAYS STUDYING THEIR FORTUNES.

REQUIRES A GOOD IMAGINATION
THREE DOTS IS YOUR WISH, AND IF NEAR THE TOP YOU GET IT—A RING MEANS MARRIAGE, A SMALL SPECK A LETTER.

(Written for the Tribune.)

The latest aspirant for honors in the art of foretelling the future, which seems to stand for the fad of the hour, is a slender little gray-eyed priestess, who announces on her card, "Fortune telling by tea grounds, clairvoyantly." Of all the methods of an elder day art which are in survival, fortune telling by tea grounds may be said to be the oldest method known and the one believed to be the truest. Our grandmothers had many superstitions connected with the turning of the cup, superstitions which are now part of today's creed.

In the first place we must drink a little of the tea, which should be hot, and then turn out the rest, being careful not to turn out the grounds at the

same time, and also being careful not to look at them, as this is considered to bring ill luck.

Having turned the tea all off, turn the cup completely over in order that not a drop of water remains, for this would mean tears. Then having turned the cup slowly around toward you three times, at the same time wishing the wish of your heart, set the cup down a moment, resting it against the edge of the saucer or any convenient plate. It is very necessary that the cup should rest in this manner a moment, as putting it flat down upon the table would be a tempting of ill fortune, according to tea grounds tenets. Another means of courting ill luck is to interfere with anyone else's fortune by presenting your cup while the other is being read. Only one person's cup at a time must be read. Another unlucky omen is to look over the fortune teller's shoulder when she is consulting your cup or to look in your cup at all. A person versed in the laws of teacup witchcraft will never point out anything in the cup with her finger, but will rather use a convenient spoon, fork, match, pencil, etc., for to point with the finger brings ill luck.

According to all authorities, three small dots in a perpendicular row always stand for the wish, and the nearer they are to the top of the cup the quicker the wish will be obtained. Three small dots that form a triangle mean unlooked for good luck in the fulfillment of the wish. A triangle is always a fortunate sign. So also is an anchor, a horseshoe, a cross and a flag. A flag means that something of unusual advantage to the person is about to occur, or some unexpected good news. Where the grounds are well bunched together and it is clear all about them, it promises that everything will go well with the seeker after the future. If on the contrary the grounds are scattered about confusedly there will be much confusion over some event, or something disastrous will happen to the fortune seeker. The grounds surrounded by fine, dust-like particles signifies trouble, and drops of water standing in the cup stand for tears. The same fine, dust-like grounds bunched together at the bottom or side of the cup is a sum of money. A small ring in the midst of the regular grounds means an invitation.

A large, very round ring perfectly closed means an offer of marriage to a single woman, some fortunate undertaking to a married woman and a business offer to a man. Should the ring enclose a number of small specks it means an offer of marriage from a wealthy man, or a business transaction in which money is concerned. A very large opening stands for a body of water and a broken ring signifies a disappointment. The straight stick like grounds are supposedly people, light or dark according to their color and short or tall according to their length. A very small stick means a child. To have the

A delightful illustration by G.Y. Kauffman accompanied the piece. *From* Tribune *microfilm.*

stick or person in a horizontal position is sure to mean illness, and should the larger end of the stick, which is supposed to be the head, be lower than the other end it signifies death. The tea grounds often form in semblance of a person generally standing for the person whose fortune is being read, especially if found on the right side of the cup. Should the grounds bank up in two distinct places the person is about to make a change to another place, large or small as the banking may indicate. A long trailing line of very fine

grounds foretells a large journey, and if connected with a large opening of the grounds a journey by water. A boat also foretells traveling by water.

A fish is said to bring good luck in business and it is also supposed to be a suitor in marriage. A small speck near the top of the cup means a letter, larger ones standing for a package, or trunk if with a person. Look out for the person with a small bunch of grounds at his back. He is coming to you with a lot of gossip or will talk about you. A bird flying upward in the cup signifies a pleasant letter, but flying towards the bottom it is the bearer of unpleasant news. A horse running is hasty and important news. A horse is always a friend; so also is a dog. In fact, most every animal signifies good luck. A rooster crowing is great success of some kind. A turtle signifies a long life or exceptionally good health. An eagle is a friend in need. A dangerous enemy is a snake, especially if it appears at the top of the cup. If it is in the bottom of the cup, supposedly under foot, it can do no harm, but warns one to be on his guard. If it is particularly thick in appearance it is a woman.

A bridge is an important undertaking or a departure of some kind which will be successful if the foundations at either end seem strong, otherwise it will be disastrous. For the grounds to form themselves into a pyramid is extremely lucky; so also if they form into flowers. A wreath of flowers signifies a valuable present, either money or jewels. A half moon or a star foretells a lucky investment or unexpected money. Perhaps the very luckiest formation of the grounds is in the form of a tree. This foretells all manner of success and is especially fortunate if well balanced in shape, and if a person, one's own self presumably, is protected by it.

Minnetonka's Up-to-Date Hermit

AUGUST 1, 1897, *MINNEAPOLIS TRIBUNE*

*F*rank Halsted, a New Jersey native, settled on Lake Minnetonka in 1855. He served
in the U.S. Navy during the Civil War, commanding a Union gunboat on the Tennessee
and Cumberland Rivers in 1863–65. After the war, he returned to Lake Minnetonka and
built a cabin that came to be known as the Hermitage. Some years later, he went into debt
to build a steamboat, but the stress of owing money apparently was too much for this "man
of erratic habits," as the Tribune described him upon his death. In July 1876, a few
days after he was last seen at his cabin, a fishing party found his body floating in the lake,
a stone-filled sack tied around his neck. The coroner ruled it a suicide. Abiding by his will,
the citizens of Excelsior buried him on his property, not far from the cabin.

This brings us to his brother, George Halsted, who is profiled in the Tribune story here. The
elder Halsted traveled from New Jersey to Minnesota to take care of his brother's affairs. George
apparently found Minnetonka much to his liking. He moved into his brother's cabin and assumed
his brother's title, "the Hermit." But George wasn't a recluse. He welcomed paying guests who
came by steamboat to tour the curio-filled cabin and chat with its well-read and well-spoken
occupant. By the 1890s, thousands were visiting the Hermitage every summer.

You will notice an extra a (in Halstead) in one of the subheads atop this 1897 profile.
It's a common misspelling, or perhaps even the correct spelling. In story after story published
after the brothers arrived in Minnesota, the Tribune alternated between the two spellings.
Google searches produce similar results today. But "Halsted" seems to be the dominant
spelling, despite the extra vowel in the Lake Minnetonka bay named for the two men.

George Halsted died four years after this story was published. A fire consumed the
Hermitage, with him inside, in 1901. In accordance with his will, he was also buried on
the property, next to his brother.

AN UP TO DATE HERMIT

UPPER LAKE MINNETONKA HAS A STAR ATTRACTION IN THE HERMITAGE.
MAJ. GEORGE B. HALSTEAD HAS LED A SOLITARY LIFE THERE FOR 21 YEARS.
SOME OF HIS PECULIARITIES AS WELL AS GOOD QUALITIES.

Standing conspicuously forth among the multitude of attractions strewn by nature with lavish hand about the shores of Lake Minnetonka, imparting an endearing charm, are two real curiosities, the Hermitage and Crane Island. Apart from the magic spell of their names, each is vested with talismanic powers, and acquaintance rebukes the unromantic, under the spell of a subtle enchantment. Few people go to Minnetonka without visiting the upper lake where these interesting objects are situated.

Of these two, by far the largest share of attention falls to the Hermitage, with its bright, hospitable occupant known as the hermit. The door is never locked, and every visitor is welcome. Unlike the nominal characters of fiction, the solitary inmate of the curious old structure evinces a fondness for company, and is personally known by those who have seen him, as a conversational entertainer of exceptional ability.

These and other attractions have stifled the aversion commonly met with in the popular mind for those of his kin, and Maj. George Blight Halsted has secured respect from the thousands who have visited his home. He does not object to being called the hermit, in fact he rather likes the distinction, and none need fear of offending him by speaking of his cozy little dwelling on the extreme upper shore of Lake Minnetonka as the Hermitage, even though the owner and occupant is within hearing. By his companionable qualities he has improved the "order of hermit," so to speak, bringing it strictly up to date, but even with these traits considered he may rightly be considered an unusual man with eccentricities sufficiently pronounced to give him an added interest.

Secret influences have wrought a change in the life of Major Halsted. It was the death of his brother at Minnetonka, for who he entertained such strong affection, that attracted him to this section of the West, but there may have been a love affair back of that. He is thought to be about 80 years of age. The supposition is reasonable in view of the fact that he graduated from Princeton in 1839. He always says he is 48 years old. Lineally, he deserves attention as he comes from a family of lawyers, politicians and fighters. His father was chief chancellor of the state of New Jersey. The major earned his title in the late rebellion; he is a linguist of enviable attainment, and a frequent contributor to magazines of the day.

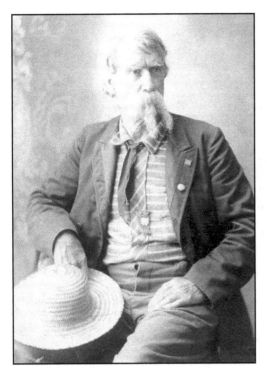

Major George Blight Halsted, who arrived in Minnetonka in 1876 to bury his brother, made the Hermitage his home. *Courtesy Excelsior–Lake Minnetonka Historical Society.*

It was in 1876 that Maj. Halsted came to Minnetonka. His mission was to bury the remains of his brother, Frank Halsted, whose sudden demise followed his completion of the steamer "Mary." Frank was laid to rest in a plot of earth near the Hermitage. The spot is marked by the American colors, and each evening when at home the major sits in sorrow beside the place.

The Hermitage is a small, unpretentious frame building with picturesque surroundings, situated near the water's edge, about a mile above Zumbra Heights. Visitors have been largely responsible for making the place what it is, for inside and outside it is literally a gathering of curiosities. No one thinks of making a call without leaving a card, and the fashionable thing at the Hermitage is to imprint one's name with a knife in the walls of the dwelling. Within are to be seen relics and antiquities of all descriptions.

If Maj. Halsted intends keeping up his life of a hermit he will soon have to secure additional accommodations. The present one is almost used up, between the cutting of names on the walls and the fullness of the rooms with curios. In the latter there is little space to turn around. Lately visitors have taken to writing their names on pieces of paper which are pinned to the window curtains, and anything else that will yield to a pin. Once there they are almost sure to remain, for the hermit never seems to disturb anything, although he cares for the house himself. Visitors are so impressed with the confidences he reposes in them that they are governed by an appreciative regard and leave things as they find them.

"I never lock my doors day or night, whether I am at home or away," said Major Halsted. "I think it is safer to leave them open and I am not afraid of

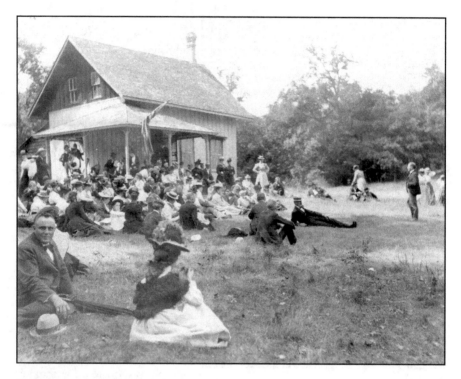

The Hermitage drew big summer crowds. Here, Minneapolis members of the Ohio Association lounged on the grass outside the cabin in 1898, listening to a speech. *Courtesy Hennepin County Library Special Collections.*

people stealing things." It is possible that if his home was nearer Minneapolis it would not require a score of years for him to have a less firm confidence in human nature. As it is though, tramps stole a rifle from his house last year.

With a true gentlemanly instinct, the hermit is always polite and obliging to the ladies. Indeed, his gallantry became well-known when as captain of the "Mary," after his arrival here, he drew upon his head praise from those members of the fair sex who engaged transportation on his boat. By some means a feeling other than friendly sprang up against him in the circles of competing lines, and one time he was run down in the Narrows by a lake captain in charge of the Belle of Minnetonka, when he was in a small boat. He barely escaped drowning. For that act he never forgave the company, and to this day refuses to allow their boats to land at his dock, the loss to the company being in the thousands of dollars. Once, when a boat persisted in approaching contrary to the orders of the major the latter stood at the dock with a shot gun, threatening to shoot the first man who stepped ashore, and

stating the next would go through the captain. There was little doubt he meant what he said.

The gentleness of his nature is shown in the affection with which he welcomes birds, which are so tame about his place that they stand on his knee. He never kills snakes and considers them perfectly harmless. He can tell the cry of a frog when caught by a snake, and at once saves the former from its enemy. He is a capital story teller, and discourses with interest on current topics, or entertaining reminiscences. He earns some money by hauling wood in the winter, and draws a pension. When eating at a restaurant he displays partiality to puddings, usually ordering the complete menu list. It is his wish that his home and property be given to the widows and orphans of old soldiers.

A Frightful Cemetery

NOVEMBER 6, 1899, MINNEAPOLIS TRIBUNE

*H*ere a nameless Tribune *reporter spins a ghost story worthy of any campfire. The scene is set near an abandoned graveyard in northeast Minneapolis, most likely Maple Hill Cemetery, the city's first, established in 1857. Over the next thirty years, about five thousand bodies were buried there.*

The cemetery at Broadway and Fillmore fell into disrepair in the 1880s. Plots were cheap—just eight or nine dollars, according to an 1889 Tribune *story—and recordkeeping was shoddy at best. Some remains were buried no more than two feet deep. Neighbors feared that the poorly maintained burial ground was a health threat and began a campaign to have the remains moved and the cemetery closed. By the time this story was published, the removals had already begun and burials ceased. But with no source of funding, most of the remains and markers remained there untended for years. The grounds were "loaded with rubbish and so neglected that many of the caskets are exposed to view," the* Tribune *reported.*

The city's Park Board took possession of the land in 1908 with the idea of restoring a portion of the cemetery and reserving ten acres for a children's park. A playground was established there in the summer of 1916, but the adjoining cemetery was still largely a mess. By that fall, the neighbors had had enough of the eyesore: under cover of darkness, about thirty men hitched up three teams of horses and cleared the land of debris and headstones, dumping the markers in a ravine on the west side of the property. Eight men were implicated in the "Maple Hill Raid," but only two faced vandalism charges, and they won acquittal at trial.

Soon after the raid, the Park Board removed most of the remaining markers, and Maple Hill became firmly established as a park. A skating rink, a warming house, horseshoe pits and other amenities were added. Boy Scouts and Girl Scouts gathered there for activities. The

park's hockey teams enjoyed success in citywide competition. In 1948, it was renamed Beltrami Park, after the Italian American explorer of the nineteenth century. But signs of the park's past are still visible to this day. At least two small gravestones can be found amid the grass and trees on the park's northwest side, not far from a monument to forty-six Civil War veterans who were buried there.

GHOSTS

WEIRD ADVENTURE OF A YOUNG WOMAN WHILE WALKING NEAR A CEMETERY IN NORTHEAST MINNEAPOLIS.

"Help! Help! The ghost will get me!" shrieked Ida Olson, last evening, as she rushed up to a pedestrian who was walking in Central avenue, near the abandoned cemetery in Northeast Minneapolis.

The girl, who is a domestic, was frightened so badly that it

GRAVES DESECRATED BY INHUMAN GANGS

GHOULISH ORGIES IN OLD MAPLE HILL CEMETERY.

Residents Rise in Anger Over Unnatural Practices.

SACRED CHARACTER OF PLACE IGNORED OND CASKETS ARE REMOVED.

A scandal which to all appearances seems utterly beyond comparison with any which has hitherto been found to exist in this city has been unearthed in Northeast Minneapolis, where the old, condemned and abandoned Maple Hill cemetery has been used for purposes which would turn the hardest heart to shame.

The cemetery, which is located on

In April 1907, the *Minneapolis Tribune* reported that Maple Hill Cemetery was in "deplorable condition." Rain had washed away sand at the western edge of the cemetery, exposing caskets to view. And children playing baseball had broken gravemarkers to pieces for use as bases.

was impossible for her to talk in a coherent manner, and for a time it was feared she had been driven insane by fright. She declared that while walking past the old cemetery with Ole Johnson, her sweetheart, a white object had arisen from one of the neglected graves, and, with an unearthly yell, had pursued them.

Ole, she said, had deserted her at the first sign of danger, and had left her to her fate. She was sure the object she had seen was a ghost, and she declared with equal firmness that it was the ghost of a man with horns, for she had seen the horns on his head, and had noted further that he wore a long white beard. Several times while telling her story she became hysterical, and it was with difficulty that she could be induced to continue.

John Adams, employed in the Columbia Heights mills, was the man whom she accosted on the street, and he at once took the girl into a drug store, where her story was related. At first it was thought Ida had been drinking, but there was not the slightest smell of liquor on her breath, and she was evidently badly frightened. While she was talking her sweetheart entered the place, and cried with joy at seeing the girl safe and sound.

Johnson, who is a laboring man, and a fairly intelligent appearing young fellow, told a story quite similar to that related by the girl, except that he said he had, instead of running away from the ghost, run towards it, in an endeavor to find out what it was.

Reminders of Beltrami Park's past as a cemetery remain to this day. *Photo by author.*

SEARCHING PARTY FORMED. Several persons were in the drug store at the time, and they at once formed a party and paid a visit to the old cemetery. As the abiding place of the dead was approached the courage of John disappeared, and he lagged behind. The girl, on the contrary, was fairly brave, now that there were other persons near by, and she led the party to the place where she said the ghost had appeared.

The spot from which the figure had arisen proved to be a slight depression on a mound, and the crushed down leaves and dead grass showed that a body of some sort had lain there. The adventure was becoming serious, and

two or three members of the party did not venture as far away from their companions as they had done before the depression was found.

An extended search of the locality was made, but no trace of a ghost or anything looking like one could be found. Just as the party was about to give up and return to Central avenue a gasp of horror burst from the lips of Johnson, and he sank to the ground in a heap. A short distance away, only just visible in the dim light, was a white figure, with horns and a long white beard, just as Miss Olson had said.

STRANGE SOUNDS HEARD.

As the little party looked a sound that cannot be described came from the object, followed by a silence that was painful in its intensity. For a moment no one moved or spoke; then one of the more adventuresome

The abandoned cemetery was the site of drinking parties large and small. No doubt a few Hamm's bottles were among the rubbish that made neighbors unhappy. *From* Tribune *microfilm.*

members of the party started in the direction of the ghost, carrying a revolver in his hand.

"Speak or I'll shoot," he called, as he scared the object.

There was no response, and again he repeated his command. This time the object moved a trifle and seemed to advance toward the party. As the man with the gun was about to fire there broke upon the silent night a plaintive:

"Ba-a-a-h!"

Then a large white goat, with a beautiful pair of horns and a magnificent bunch of gray whiskers, walked up to the men and began nosing around as if expecting to be fed. The reaction was too much for the party, and the various persons laughed until they cried. Meantime Johnson had disappeared, and Miss Olson was sent to her home in University avenue northeast.

The goat, it was learned later, has been pastured in the old cemetery and the surrounding locality during the last summer, and he has been in the habit of sleeping around in any old place, and of going up to passers-by and asking in his dumb way for something to eat. Who the owner of the goat is could not be learned.

Quite a Puzzler

NOVEMBER 13, 1904, *ST. PAUL GLOBE*

This cruel "puzzle" appeared on the Globe's *"Girls and Boys Page Conducted by Polly Evans." Polly must have been a wicked, wicked person. Her instruction on this puzzle: "The square is full of straight lines that criss-cross each other and make a confused maze of lines. Can you count them and tell Polly Evans how many there are?"*

How Many Lines?

FOLLW-UP: Polly failed to provide an answer for this mind-bender. Sometimes, kids, you're on your own.

The Mysterious Mr. Sly

SEPTEMBER 23, 1906, MINNEAPOLIS TRIBUNE

*N*ewspaper circulation managers, struggling to maintain paid subscriptions in the Internet age, may be interested in reviving this century-old idea. In September 1906, the Tribune introduced readers to the "mysterious Mr. Sly," an anonymous easterner hired to walk the streets of Minneapolis and elude readers competing for a $250 prize for his capture. Each day, the paper published Mr. Sly's detailed accounts of where he'd been and whom he'd met the day before, as well as offered clues about his appearance and future whereabouts.

The rules were simple: First, each participant needed to carry a current issue of the Tribune in hand (the morning edition before noon; the evening edition thereafter). Second, the player had to present the paper to the suspect and place a hand on him. Third, the player had to address the suspect with these words: "You are The Tribune's Mysterious Mr. Sly. Do you deny it?"

If you had your hand on the actual Sly fellow, he would not deny it or run away. He would gladly accompany you to the Tribune building to help you collect the prize of $50 or more. This detail seemed to elude many players, who refused to take no for an answer when ordinary Joes denied having anything to do with Mr. Sly. One fellow who bore a vague similarity to Sly was dragged to the Tribune eleven times by folks eager for a prize that amounted to about $6,500 in today's dollars. He was a good sport about it, considering that the Tribune made no effort to compensate him for his trouble.

Despite the legal pitfalls, imagine the buzz that such a contest would create. "Are you Mr. Sly of the Tribune?" "Did you see where the Tribune's Mr. Sly was yesterday?" "I see that Mr. Sly of the Tribune has shaved off his mustache." "You are Mr. Sly of the Tribune—do you deny it?" And everyone carrying a fresh copy of the paper—plus a receipt for a six-month or yearlong subscription, for a shot at a $150 or $250 prize—for days on end. The price of one copy of the Tribune in 1906? One cent.

REWARDS FOR CAPTURE OF MYSTERIOUS MR. SLY

The Tribune will pay one of the following Rewards for Capture of MYSTERIOUS MR. SLY if conditions below are complied with:

$50 simply for his Capture. (See conditions.)

$150 if Receipt shown is for Six Months' Paid-in-advance Subscription.

$250 if Receipt shown is for One Year's Paid-in-advance Subscription. The Receipt (a) must be shown MYSTERIOUS MR. SLY when he is accosted; (b) must be for Paid-in-advance Subscription to The Tribune beginning any date after Sept. 24, 1906.

ALL THREE CONDITIONS MUST BE OBSERVED IN EVERY CASE.

THE CONDITIONS

First—Lay your hand on MYSTERIOUS MR. SLY.

Second—Show Mysterious Mr. Sly Latest Issue of The Tribune.

Third—Say to him: "You are The Tribune's Mysterious Mr. Sly. Do You Deny It?" (All of these Conditions must be observed with or without receipt or capture will not be admitted).

All Tribune Employes, their Families and Relatives and all Personal Acquaintances of Mysterious Mr. Sly residing outside of Minneapolis are barred.

Mysterious Mr. Sly will positively admit capture when made according to above conditions, and only on his endorsement will reward be paid. Payment of Reward at The Tribune office.

The contest rules were published daily in the *Tribune.*

Mr. Sly managed to elude capture for more than two weeks. Here are highlights from his daily report, plus a few interesting sidebars.

LIBERAL REWARDS FOR CAPTURE OF THE TRIBUNE'S MYSTERIOUS MR. SLY
WHERE IS THE TRIBUNE'S MYSTERIOUS MR. SLY?

On and after Tuesday next the Tribune offers liberal cash rewards to the man, woman or child who finds the Tribune's Mysterious Mr. Sly and brings him to the Tribune office.

He will make his first appearance in public—on the streets, in business places or the theaters Tuesday, coming when and where nobody will be advised beforehand.

It is for some clever, observing person to find out where he is, lay hand on him and earn the smallest reward paid by showing him a copy of the latest issue of the Tribune and letting him know that you have got him by addressing him thus: "You are The Tribune's Mysterious Mr. Sly. Do you deny it?" If you have complied with these simple requirements and you actually have got hold of The Tribune's Mysterious Mr. Sly he will admit it; he will not deny it.

If you find a man 5 feet 10 inches high, weighing 160 pounds, with dark brown eyes and light hair, 45 years old, who is trying to dodge you, intercept him. Be sure you have a copy of the morning edition of the Tribune up to the time the afternoon edition appears on the street, and after that a copy of the afternoon edition until the next morning edition appears.

To begin with, you have his description. When he begins to tell in the Tribune of his adventures you will see his pictures…

This is an amusing feature, or game, which the Tribune offers for the entertainment of its readers. If you have no time to search for the Tribune's Mysterious Mr. Sly you will be entertained with his own signed stories of his adventures.

He will act the part of the fugitive as naturally as possible and without the spectacular effects.

He may or may not announce where he is going to be, but as he will be in the business street of the city daily, going into business and other public places, you will have no difficulty finding him.

The surest and easiest way to pick up his trail is to post yourself on his movements by reading carefully his daily stories. There you will find his methods, which he cannot conceal any more than as if they were plain foot prints following him from place to place.

Remember, it is on Tuesday that he can first be found.

On September 24, 1906, there was the following:

THE MYSTERIOUS MR. SLY WILL BE ON STREETS TODAY
WITH A PRICE ON HIS HEAD HE WILL GO ABOUT TOWN WITHOUT ASSUMING ANY DISGUISE.

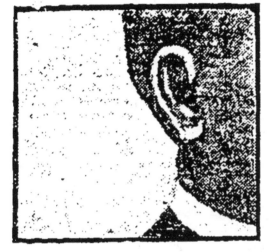

Top: Photo clue no. 1: How he parts his hair. *From* Tribune *microfilm.*

Bottom: Photo clue no. 2: Sly's right ear. *From* Tribune *microfilm.*

Everyone will watch all others today to get a line on the Tribune's Mysterious Mr. Sly.

At just what hour he will make his appearance in town nobody other than himself knows. It is well to be prepared to meet him at any time and place.

When he does show up he will not be bashful, will not lose any chance to put himself in the power of men, women or children he meets.

He will be expected to take many unusual chances and make the game the more interesting. As he is not permitted to disguise his features it would seem that after he has once had an interview with a person it would not be difficult for that individual to recognize him afterwards.

Who is there who does not enjoy unraveling a mystery? It is for that interest the majority of the people take in this thing that the Tribune puts out the Mysterious Mr. Sly. Believing that even those who have not time to enter into the chase will be entertained by reading the Mysterious Mr. Sly's own stories of his adventures, the Tribune has taken up this feature convinced that its novelty will appeal to all of its readers...

How Long Will He Last?

As the Tribune's Mysterious Mr. Sly will not write a line that cannot be verified—as he actually does all that he claims to do, it follows that every day he will get more and more into danger, drawing the pursuit closer and closer to his heels. It is then plain that from his first appearance he will be in danger of capture every moment. How long he will be able to keep it up is an interesting query.

On September 26, 1906, there was the following:

Do You Think You Saw the Mysterious Mr. Sly Yesterday?
His Own Story Tells of His Arrival and First Journeying Around Town,
in Which He Gave a Policeman the First Chance for the Reward.
The Cars Carried Him Around as Any Other Passenger, but He Made
a Few Visits on Hennepin Ave., and Got into the Company of
Very Nice Boys.

(By The Tribune's Mysterious Sly.)

Where the Minneapolis and St. Paul car No. 927 came to a stop this morning was a large plaza or square formed by the junction of two streets.

For my first introduction to Minneapolis, the scene of my future exploits, this large, open crossing gave me a most happy impression. Certainly I shall find this a city of wide streets—constructed on liberal lines, so different from the East—I thought.

But I was not out for idle reflection. Stepping towards the walk on the right hand side of the car, I nearly ran into a policeman, apparently stationed there, who was moving slowly around the corner. I gave him a quick glance which gave me the impression that he was not observing me, unaware of the prize that that St. Paul car had dropped in front of him in my hurried look I caught the number on his hat indistinctly, it appearing to be 92. He was a man a trifle under medium height with dark moustache. Probably he would weigh 170 pounds, being as I could see, well built—a man who physically can take care of himself.

Even so, though he let $250 in good cash trot out of his front gate, and after I had given him the first chance of anyone in Minneapolis…

I got on a Como-Harriet car which some one told me would take me up Hennepin avenue to Twenty-first or Thirty-first street. I don't recall which. When I stepped inside the car I saw a man in gray, or mail carrier,

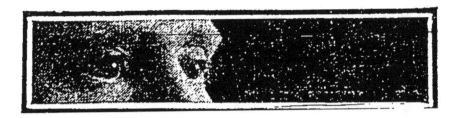

Sly's eyes. Does that help? *From* Tribune *microfilm.*

in uniform, take a seat next to the door. He opened a book and was at once buried in its contents. Here is where I leave a pretty clever-looking fellow a good clue by which he can find the Tribune's Mysterious Mr. Sly, said I to myself. So, leaning over from where I stood next to the door, I got my head down so as to get the number on his cap.

It was Mail Carrier No. 87 I was offering $250 and he didn't know it. My face was almost in his and I had to lean over in front of a fellow who sat at his side to get in that position.

Perhaps Mail Carrier No. 87 may doubt that the Tribune's Mysterious Mr. Sly was at his elbow on Como-Harriet car 905 when, today at about 11 o'clock, it was pulled away from Washington avenue. Let me hand him out positive proof I was there. The book he was reading was a law book of some sort, and I got the impression he was studying law. When I looked on the book it was open at pages 98–9. He will support what I saw and, furthermore, agree with me that the headline in the middle of page 98 read: "Sloan & Garner." The other lines I couldn't see.

Two hundred and fifty dollars would help this mail carrier a long ways into the study of law...

On October 1, 1906, there were the following headline and subheaders:

MYSTERIOUS MR. SLY VISITS TROLLEY CAR HOUSE AT 31ST ST.

DROPS IN AMONG WAITING CREWS, GIVING THEM A GOOD CHANCE TO
OBTAIN PERSONAL INSPECTION OF HIM.
DESCRIBES PEOPLE HE MEETS ON THE STREETS GOING TO CHURCH AND
ENJOYING THE BALMY AIR OF PERFECT SUNDAY.

On October 2, 1906, there was the following:

Mysterious Mr. Sly Shakes Hands with Boss on Job
Gets in with Gang on Plymouth Avenue Laying Curb and Gets Name of Man He Is Talking With.
Boldly Going through that Part of City, Meets Several Others, and Talks with Them.

(By The Tribune's Mysterious Sly.)

That I am getting into close quarters where danger of capture threatens me at every step was apparent yesterday when I took my morning stroll through the business streets.

The young fellows, those who have time at their disposal, are camping on my trail. I saw them, one after another, on Nicollet avenue, and First avenue, and on Third street near the post office, and on Fourth street all along the curb from First avenue to Hennepin avenue. If you will observe during the middle of the day, you will see them, too, watching every man who passes up and down the street and occasionally consulting the palm of their hand. They are not palmists, but are what I call regulars. They have clipped the several sections of the face of the Tribune's Mysterious Mr. Sly from the columns of this paper and pasted them together. The pieces are not of a size to match, but in spite of that one can get a good idea of my features.

This they carry in the palm of their hands, and when they see one who strikes them as familiar they compare the passing individual with the restored picture. I ought to make it easy for one of them to get a line on the Mysterious when he gets in their way...

Another man in this town who ought to get his fist on the Tribune purse in the course of a day or two I found up on Plymouth avenue directing a gang of men at work laying a concrete curb. It happened this way:

I was coming down the avenue below Emerson avenue and was watching

His nose and mustache. *From* Tribune *microfilm.*

the workmen mixing the concrete in big boxes. The form was built up for a considerable distance, the sides held in their position by means of clamps. At the lower end of the working force I noticed the man in charge of the work out in the street removing his coat. As he came over onto the walk I approached him. He was going to lay the coat upon the grass.

"Warm enough to strip?" I exclaimed, as we came together, questioningly.

Having thrown his coat down he turned toward me and with a smile nodded an affirmative to my remark. Then came a surprise for me. He walked up to me and extended his hand.

I grasped it, wondering what it meant. Possibly he thought he knew me, or perhaps it was a little act of courtesy. He didn't explain or call me by any name. He offered his hand and I accepted it, and we shook hands. I'll admit that I was nonplussed. However, it was a very agreeable incident.

Without any remark he turned his attention to the workmen preceding me down the walk. Then the force of the joke on him struck me.

He had taken hold of the hand of The Mysterious Mr. Sly, the man for who the Tribune offers a reward of from $50 to $250, and he didn't know what he had missed by turning away and letting the good thing slip from

his grasp. I felt so amused over the situation that I couldn't repress a smile. It was worthwhile to know who that man was.

He came back up the walk when I had gone a few steps and I turned and stopped him as he went to go by.

"I don't know as I can recall your name," I said, addressing him.

A silhouette drawn by a *Tribune* artist. *From* Tribune *microfilm.*

"Downs," was his reply.

So it was Mr. Downs, contractor or city inspector, whichever he may be—at any rate, boss of the job on Plymouth avenue—who is the first man in Minneapolis to shake hands with the Tribune's Mysterious Mr. Sly.

Now that he reads of the incident he will remember exactly my personal appearance and will lose no time in starting after that Tribune reward.

If Mr. Downs should get hold of that hand again, he should not let go of it until he has made the capture effective, according to the conditions…

THOUGHT HE HAD SLY

The interest that is being taken in the universal quest for the missing Mr. Sly is clearly shown by an incident that took place in the city editor's room on the fourth floor of the Tribune building yesterday afternoon. The incident was due to the determination of one well-known resident of the city to locate the missing Sly person, and it was owing to the close resemblance to the mysterious man that half of Minneapolis' population is now trying to catch that the well-known resident, who is none other than A.E. Wright of 85 Ninth street south, was led to believe that the physician and Mr. Sly are one and the same person.

It was at the corner of Nicollet and Fourth street that Mr. Wright chanced upon the man whom his imagination at once told him was the elusive Mr. Sly. The medical man was sauntering along the avenue, and his casual air, together with the fact that he bore a marked resemblance to the Tribune accounts of Mr. Sly, caused Mr. Wright to turn around and follow the man for several rods.

A few minutes of close scrutiny led Mr. Wright to the conclusion that he had at last found the man for whose identification there is a heavy reward.

"You are the missing Mr. Sly," were the words that aroused the physician out of a brown study.

The mention of the mysterious personage at once provided a key to a situation that with other men and under other circumstances might have proved embarrassing. With a swift denial of any relationship to the much wanted man on his lips, the physician suddenly conceived the idea of having a little fun of his own out of the case.

"Well, supposing I am the missing Mr. Sly, what are you going to do about it?" His reply, enhanced by a quizzical smile that began to play about the corners of his mouth, had the immediate effect of leading Mr. Wright to believe that at last the missing Mr. Sly was captured, and the large crowd that had congregated during the colloquy were plainly of the same opinion.

Left: A silhouette drawn by another *Tribune* artist. *From* Tribune *microfilm.*

Below: Sly visited both Powers and Yerxa, mingling with customers and clerks. *Courtesy Hennepin County Library Special Collections.*

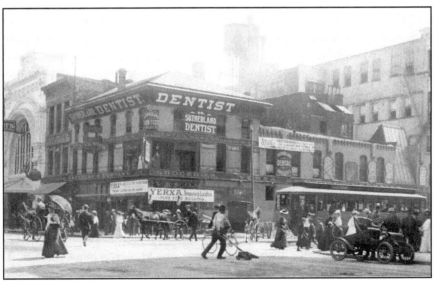

"It's to the Tribune office for us both. That's what I am going to do about it," and linking his arm in that of his captive, Mr. Wright steered the man of powders and pills to the big building with the white front on Fourth street.

There they took the elevator for the fourth floor and in the process of time landed in the city editor's room. Once there, the physician continued to

wear his air of mystery until Mr. Wright was more than ever convinced that he had attained the distinction of capturing the missing Mr. Sly. Just how the incident could have ended is a question, had not an acquaintance of the physician chanced to enter the room at the moment when Mr. Wright's credulity was at its height and put an end to the highly interesting situation by calling his doctor-friend by name.

After the mystery was cleared up the two principals to it consented to sit for their pictures under the hand of the Tribune's artist.

On October 3, 1906, there was the following:

Clerks in Large Store Get a Call from Mysterious Mr. Sly
In Powers' Visits Toilet Goods and Book Departments and Gives Other Clerks a Fair Show.
Roams at Large in Minneapolis Dry Goods Co.'s Store, Visiting Different Floors and Makes a Selection of the Rugs.

…Coming through First avenue from Sixth street today as far down as Fourth I found the regulars out in greater numbers. A group of the Old Guard watching at the cigar store corner, a place they do well to picket for not a day passes that I do not go by that corner, were warming themselves in the sun. I turned the corner and walked by The Tribune office, going to Nicollet avenue and there turning south. I walked up to Sixth street and swung around into First avenue where I followed the east side of the street until I got opposite Powers where I crossed and entered that big store, the first time I had ever been inside of it.

Up Against Two Clerks.
A great many customers were moving about in the aisles. I stopped a moment inside of the entrance and looked around. At my left were tables loaded with small goods and beyond them stocks of books. At my right it was the same arrangement of goods and what attracted my attention and gave me the hint of a reason for coming in was a big display of toilet articles.

Now when I go into a store I have no plan of action. I depend on what I see to offer me suggestions. Naturally I take a little time before acting. It was only a moment in this case that I took to decide.

In Conversation with Them.

Down the middle aisle, ahead of me and at the left, I saw two clerks standing side by side and having nothing to do. There is a chance to hand out the Mysterious, I thought. Either one of them would pick up $50 in a minute if it came his way. So on the spur of the moment I walked directly to them.

One was short, stout built, with blond complexion and no beard. The other was taller, slimmer, with a healthy brown in his face and sporting a small black mustache. I put myself close in front of them and looking directly at the shorter man addressed him.

"Where is the department of men's toilet goods," I asked.

"What is it you want to get?" he asked, in a pleasant tone. Now, I had seen where the toilet goods were located but had made that my excuse for giving these amiable clerks a chance for The Tribune money.

"Brush and comb," I replied.

"Back there in the first aisle, around to your left," he directed.

Pretty Clerks Attract Sly.

That was where I had first decided, on entering the store, to go, for I had observed two pretty clerks of the "sweet sixteen" style at that counter, who I felt ought to have really the best show for the reward, supposing of course that like most of the thousands of young women who work in the stores for no princely pay, they would appreciate a handover of a half a hundred dollars or so.

When I reached the counter I saw for the first time that there were three of them, one, a slip of a girl in blue sitting up in a sort of loft right in front of me. I was approached by the young lady with dark brown hair, a good color in her face and wearing a white waist checked with small black lines.

She had such a nice way of asking me what I wanted that I felt ashamed to think that unless she was wise enough to tumble I should have to carry away the handsome sum of money and then tell her what a chance she had lost.

I got her to haul out a half dozen or more hair brushes, beginning with one at $1.75. I told her I wanted a brush for myself. "Anything cheaper than that?" I asked. Yes. Here was one for a dollar and a half. I had begun to feel so mean at the trick I was playing her that I decided as a matter of consolation for her to make a purchase. Now, I didn't need any brushes, so I called for something cheaper.

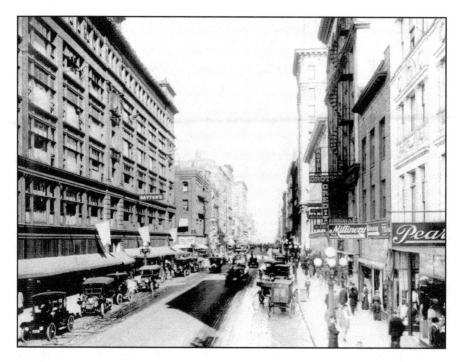

The Dayton's building is at left in this 1913 photo of Nicollet Avenue. *Courtesy Hennepin County Library Special Collections.*

ON TO HER JOB.

"Less than a dollar and a half?" she asked in some surprise.

"Have you cheaper ones?" Yes. "Please let me see them." She smiled, and I tried to "look pleasant." Here was one, she said, for a dollar. But, no, still cheaper. One for 50 cents, she said. Oh she was wise—on to her job, all right. I took the brush and pretended to examine it. What was the use of paying more than I had to, when my bureau was already supplied.

"Anything for a quarter?" I asked, feeling that I was treating her meanly in making my purchase so small.

"Oh, yes!" and she handed me out a 25-cent brush with the same agreeableness as though she was making a two-dollar sale. This made me feel easy, and friendly toward her. I bought the brush and gave her the exact change. The girl in blue wrapped it up. As I turned to go away I observed the other clerk standing close by. She had pretty blonde hair and light complexion tinted red and was dressed in white.

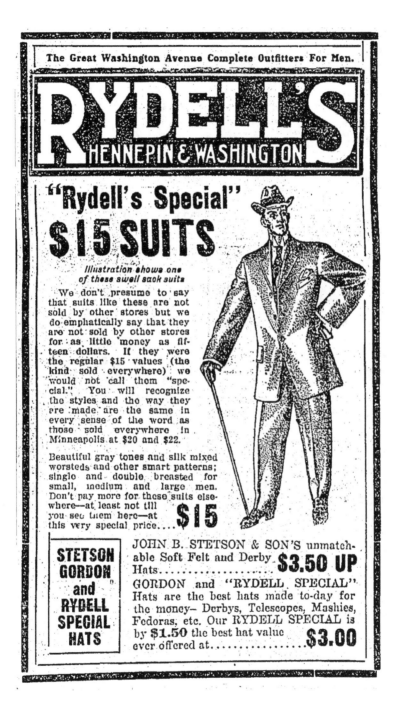

Another frequent *Tribune* advertiser was Rydell's on Hennepin and Washington. *From* Tribune *microfilm.*

On October 4, 1906, there was the following:

MYSTERIOUS MR. SLY'S QUEER ERRAND AT DAYTON'S STORE
THERE HE ALSO MAKES PURCHASE, LOOKS OVER GOODS AT SEVERAL
COUNTERS AND INSPECTS FANCY GOODS, SECOND FLOOR.
GIVES FLOORWALKER AT PHILIPSBORN'S A FIVE-MINUTE TALK THEN LOOKS
OVER LADIES' CLOAKS WHERE KEEN EYED CLERKS MAKE HIM UNEASY.

On October 5, 1906, there was the following:

MYSTERIOUS MR. SLY VISITS SEVERAL MORE LARGE STORES
MAKES THE ACQUAINTANCE OF RYDELL, THE CLOTHIER, AS HE IS INFORMED,
AND SELECTS CLOTHING.
GETS ESTIMATES FOR FURNISHING A FLAT, AND INSPECTS PIANOS, THEN
LUNCHES AT SCHIEK'S.

On October 6, 1906, there was the following:

SLY REMEMBERED BY MUSIC DEALER
A.M. CUMMINS THOUGHT MYSTERIOUS ONE A SPOTTER.
POSITIVE HE WOULD KNOW SLY IF SEEN AGAIN.
C.E. LeCRONE, LUMBERMAN, SEVERAL TIMES MISTAKEN FOR THE TRIBUNE'S MAN.

The net certainly is drawing in about Mr. Sly for everyone who has seen him once, and then been written up by Mr. Sly is on the lookout for his second appearance. A Tribune reporter went over the ground yesterday covered by Mr. Sly the day before, and was able to verify his every statement.

A.M. Cummins, the "stout built, round, full-faced gentleman," described by Sly in Schultz's piano store, said: "Yes, yes, it's all so. He seemed so interested, and asked so many questions regarding the construction of the instruments that I thought at first he was a spotter from some other store. Later I changed this view because he seemed so one-sided, and I showed him every piano in the house. Yes, indeed. I would know him if I saw him again.

A call was next made at Rydell's, and it was learned that Mr. Rydell had subscribed for the Tribune for a year soon after seeing Sly's account of his visit to that store. Mr. Rydell is working extra hours doing the Sherlock Holmes act these days, and when seen said: "Yes, the Tribune was correct in

October 5, 1906: three views of Sly. *From* Tribune *microfilm.*

everything it said about Sly's visit to my store. You bet I'd know him again if he came in. I'll land him yet, see if I don't."

From Rydell's the reporter went to Schiek's and there Mr. West who waited upon Sly was readily found and is all broken up over missing the $50 reward. "My, if I had only known it was he," he said. "I could have used that fifty, too. The Chamber of Commerce boys have been roasting me all day about missing such a chance, for a little wad of money, and if Sly comes in again I'll nail him."

C.E. LeCrone, a lumberman from Memphis, Tenn., who has been a guest at the Nicollet for the past week, has had considerable difficulty in persuading some people that he is not the real Mr. Sly.

On Wednesday evening while walking down Nicollet he was surprised at the attention he attracted. Two young ladies in particular were watching him, looking him over from head to foot, and then followed him for several blocks. When he stopped to look into a store window they stopped too and when they at length turned down a side street, he says they turned back with a look that seemed to say "I'm onto you, all right."

Yerxa

Fifth St. bet. Nicollet and Hennepin
Telephone orders promptly filled.
353—Private Exchange—353

You're Safe at Yerxa's

Fancy Wealthy Apples

20c peck.

Fine cooking and eating apples.

CONCORD GRAPES, basket **18c**

PRESERVING PEARS, peck **35c**

ITALIAN PRUNES, basket **25c**

CRAB APPLES, peck **40c**

MINNETONKA DEL. GRAPES, basket **17c**

FLORIDA GRAPE FRUIT.

NEW MINCE MEAT, lb **10c**

SAUER KRAUT, quart **8c**

MACKEREL, each **8c**

KIPPERED HERRING, 25c tin **17c**

In his travels around Minneapolis, Sly visited and wrote about nearly every major *Tribune* advertiser, including Yerxa. *From* Tribune *microfilm.*

He did not know what to make of it, but a block farther down he again met the young ladies who had evidently walked around the block and this time one of them came up to him and said: "You are The Tribune's Mysterious Mr. Sly, do you deny it?" Of course, he did.

On October 7, 1906, there was the following:

MISTAKEN FOR MR. SLY
FRANK J. EMMETT HAS INTERESTING EXPERIENCE.
COMES ELEVEN TIMES TO THE TRIBUNE OFFICE TO CONVINCE SOME DOUBTING THOMAS THAT HE HAS NO AUTHORITY TO PAY OUT $50.

"I've come to the conclusion that Sly is a mighty fine lookin' man," said Frank J. Emmett, the eleventh time he good naturedly allowed himself to be brought into the Tribune's office Friday afternoon.

Mr. Emmett is a larger man than Sly, and has darker hair. He was mistaken for Sly several times before reaching the business section, but real confusion did not come his way until after he donned a silk hat.

Mr. Emmett recalled many ludicrous incidents of the afternoon. One young man threatened a suit for damages if he, Emmett, should afterward turn out to be the mysterious Mr. Sly.

This mistaken idea seems to be quite prevalent. The truth is, Mr. Sly, when approached in the manner indicated in every issue of the Tribune, will at once acknowledge his identity. Thousands of people seem to be

of the opinion Sly will try to escape, if possible, even after capture. This is not true. Each paper has somewhere in it directions for approaching Mr. Sly.

On October 8, 1906, there was the following:

SLY'S MOUSTACHE TAKEN OFF BY NICOLLET HOTEL BARBER

NOT ONE OF DOZEN MEN EMPLOYED THERE, WHOSE BUSINESS IS STUDY OF MEN'S FEATURES, KNEW THE MAN WITH BIG PRICE ON HIS HEAD.

AT YERXA'S, SLY TALKS OF VEGETABLES AND ASKS FOR A JOB—CLERKS NOW HAVING HIS DESCRIPTION SHOULD HUNT HIM DOWN.

On October 9, 1906, there was the following:

MYSTERIOUS MR. SLY VISITS BIG LUMBER COMPANIES

MAKES A TRIP TO CAMDEN, CALLING AT THE OFFICES AND MINGLING WITH THE EMPLOYES AT THE NOON HOUR.

VISITS THE BUSINESS PLACES AT END OF THE CAR LINE, AND TAKES LUNCHEON AT THE HOME BAKERY.

MYSTERIOUS MR. SLY

Today between 12 and 1 o'clock can be found on HENNEPIN AVENUE and FIRST AVENUE SOUTH, between 4th and 6th streets.

On October 10, 1906, there was the following:

MYSTERIOUS MR. SLY WALKS SAFELY AMONG WATCHING SLEUTHS

CARRIES DUMMY PACKAGES INTO PLACES OF BUSINESS ON HIS ROUTE AND LEAVES THEM, BEARING ADDRESSES FOR IDENTIFICATION.

INCIDENTS OF HIS TRIP WHICH ATTRACTED ATTENTION FROM MEN AND WOMEN WHO WERE OUT TO GET THE REWARD AND FAILED TO RECOGNIZE HIM.

MYSTERIOUS MR. SLY

Will go into a big store to-day [Wednesday] and call for "Glowing Red" material—something in the line of neckties. "Glowing Red Necktie" is the cue. Every clerk should have a Tribune within reach.

This telling sketch of Sly appeared six days before he was captured. *From* Tribune *microfilm.*

On October 11, 1906, there was the following:

CLERK No. 83 AT MINNEAPOLIS DRY GOODS CO.'S GETS CUE
SLY VISITED TWO STORES BEFORE HE FELT SAFE TO UTTER THE WORDS THAT WERE TO MAKE HIM KNOWN TO THE CLERKS.
HAS HAIR CUT AND SHAVE AT EHLER'S BARBER SHOP AND LISTENS TO CONVERSATION CONCERNING HIMSELF.

MYSTERIOUS MY. SLY
Will be at the West Hotel to-day after one o'clock.

"GLOWING RED," that was announced yesterday, as the cue for one of the clerks in the big stores, today.

Any man who made a purchase and said he wanted "GLOWING RED," was to be taken into custody at once.

How many humorists may have gone into the stores and sprung that cue I have no means of knowing.

The real Mysterious Mr. Sly gave it out in the Minneapolis Dry Goods company's store and got away safely.

I don't like to give wide publicity to the identical clerk who let the big purse of money slip away from her. I have her name and the clerks in that store will all know who the unlucky clerk is after reading what I have got to say.

I had fixed upon Thomas' Department store to swing the cue, and it was a few minutes of 4 o'clock when I went in there through the Nicollet avenue entrance. Going down the aisle opposite the entrance I noticed one of the clerks on my right with very white hair. Just beyond on the left I inquired of two clerks for calicos and they gave me the directions.

The clerk who waited on me, a young man who by the purchase check I see is clerk No. 27, was waiting for that cue. When I asked for calico his face spread into a broad smile. On the check he wrote 22 and then a 7 over the last 2.

"What color?" he asked. Then, as he led me down the aisle he turned and asked: "Red?" He was too anxious; not at all cunning. Why should he think I wanted red? I was not out to so easily ensnare myself. He frightened away the game. It would have been the height of folly to have given him the cue. He was on the watch for it.

"Any kind of calico will do," I said…

I crossed the street and walked up the other side, entering the Minneapolis Dry Goods company's store from Nicollet avenue. At the beginning of the counter at my left I asked the girl for the cambric counter. It was in the next aisle to my right. I found the place and confronted a string of bright-eyed clerks—a half dozen together.

"I want cambric," I said. They all heard and looked at me. It was plain from their countenances, that they, too, were on the lookout. One of the shorter of the party, a blonde wearing glasses, backed out of the line and came around to the end where I was.

That peculiar style of smile I have learned to understand as a danger signal was on her countenance.

"What color?" she asked. A natural question, but not spoken by her in a natural manner. She was simply bubbling over with amusement, but she was more careful than the clerk in Thomas.

"Red," I said. Then she turned to a lady dressed in dark clothes, wearing glasses. "Mrs. ----, where are the cambrics?" It was plain that she was not the clerk who usually sold cambrics. She had butted in—I hope she will pardon the expression. She certainly showed quick wit. She wanted The Tribune reward and that was why she offered to wait on me. At once I comprehended that if I sprung the cue on her I was a goner.

She laid out a bolt of red cambric and I called for a yard. It was too late to go into another store and I had decided under any circumstances to spring the cue at that counter, and I was studying how I should do it. She had the piece partly cut off when I said to her: "Is that the only red in cambric you have?"

"No, there are several reds," she replied, dropping her scissors on the counter and looking up in a manner that denoted she was waiting for the fateful words.

"Very well," I replied, "My wife wants this for lining a work basket." I was on the point of framing another sentence with the cue in it, when she rolled the cambric up and tossed it over to Mrs. ----, to whom the sale belonged.

That was a lucky move for me, for I don't believe I could have got off the cue in anyway and escaped her. Mrs. ---- was busy for the moment and I had to wait awhile. I watched the little girl who gave me a parting look full of wisdom, and saw her go to the other end of the counter and speak to another, who began to laugh, the two looking back toward me.

Finally Mrs. ---- stepped over to where I stood and began rolling up the cambric. I handed her the exact change and she began making out the check. Then I saw the best chance I had had.

"This is as red as I can get—as bright red I mean?" I asked.

She said it was without looking up.

"What I want is GLOWING RED," I added. She kept on with her marking, not even looking up. I had slipped in the cue as I had promised and she had not taken it: That was not my fault. It was my good luck. The sale check shows that $2 got the cue...

Later that day, Sly slipped into a crowded barbershop called Ehler's and sat down for a haircut, a shave…and a quick nap.

Sly's Dream

It was my SIXTEENTH DAY, usually an unfortunate day with me. Besides, I was nervous. I had dreamed of falling into a deep cage with iron bars all around it and piled up inside were mountains of bags.

Each bag had a label. Some of them had $50 in big black figures. Others had $150; others were marked $250. Hundreds and hundreds of people were striving to break through those bars. I was working desperately with a long bar to poke them back. I could see first one bar yield, then another. "They are getting through," I said. Then I woke up.

Under the soothing influence of the barber's soft touch I began to get drowsy. I was brought to my senses by a remark I heard a barber at the farther end of the room make. I couldn't hear every word. I couldn't turn my head to see who was talking. I didn't understand anything said in reply. Evidently he was talking to a man in his chair.

What first caught my attention were the words: "Picture in this morning's Tribune." After some low, indistinct talk, I heard the barber say:

"I was speaking of the picture yesterday morning. In the Tribune." Then I caught the disconnected phrases:

"The picture with Prince Albert coat."

"He is a good one."

"He's a circus man."

"We had a good deal of fun over it. There were three of us who claimed the money. We thought the best way to do would be to divide it into three equal shares."

They were evidently discussing the Tribune's Mysterious Mr. Sly, and that same man was one of their listeners. It made me think of that famous remark of Puck's, "What—, etc."

Predisposed to nervousness when I came in, this talk set me on edge. I felt I was safe. But still I began to get more nervous; and was trying to fight it off. I squirmed in the chair, lifted myself, then fell back; and drew a long breath. I was afraid my barber would notice it and come out of his trance. So to throw him off I said that I was suffering from pain. He wanted to know what it was. And I told him of a fictitious ailment. He could sympathize with me, he said, for he also had suffered from a somewhat similar cause. Most everyone has a physical infirmity—real or imaginary.

The principal weakness at Ehler's, both of barbers and customers, was the failure to recognize the Tribune's Mysterious Mr. Sly, and after seeing all of these pictures, especially that one this morning.

Of course I left consolation money with my barber and this time I did not forget to tip the brush broom.

SLY ON EXHIBITION

During the time that the Tribune's Mysterious Mr. Sly has been operating about the streets of Minneapolis, many persons have mistaken others for the much-wanted man. In nearly every case they have brought their man to the Tribune office, and it has often been hard to convince them of their mistake.

The true Mr. Sly will be in the circulation rooms on the second floor of the Tribune building Friday and Saturday from 12:30 to 1:30 o'clock, and all who still think that they captured the Mysterious Mr. Sly are requested to call and see him and be convinced of their mistake.

On October 12, 1906, there was the following:

UNIVERSITY LAW STUDENT CAUGHT SLY AND $250.00
AFTER FOLLOWING THE TRAIL FOR SIX DAYS AND HOLDING UP EIGHT SUSPECTS HE GETS HIS MAN AT THE WEST HOTEL.
THE MYSTERIOUS MADE A TOUR OF SOUTH SIDE AND LEFT CLUES ALL ALONG HIS ROUTE BEFORE HE WAS CAPTURED.

(By the Tribune's Mysterious Sly.)

Captured at last!

And the young man who had the lucky inspiration got $250.00, the big end of the reward.

His name is H.G. Richardson, a law student at the university in his third year who will graduate with this year's class. He is 20 years old, his home is in Madison, Ind., and his Minneapolis residence is at 1324 Eight street southeast.

At 1:30 o'clock yesterday afternoon with a dress suit case in one hand and an overcoat over the arm, I walked a block and a half to the Chicago, Milwaukee & St. Paul railroad station and found two cabs waiting for fares. The driver of the first, who stood in the Washington avenue entrance to the station, stepped out, seeing me turn up to his cab, and handing him my traveling bag, I told him to drive me to the West hotel. He threw the bag up in front and I tumbled into the vehicle.

Then we were off, driving up through Third avenue south, then through Fourth street to Hennepin avenue and around the corner up to the hotel, where he drew up at the Fifth street entrance.

When he had opened the door I got out and, leaving him to follow with my bag, ran up the steps leading to the entrance. As I reached the top step I saw the form of somebody come up diagonally across the steps with more speed than I was making.

TRAILED TO HOTEL ENTRANCE.
It flashed into my mind at once that the career of the Tribune's Mysterious Mr. Sly was about to come to an end. I hurried to push open the swinging doors and get in.

In a moment I felt a tight grip on my left arm. Turning I saw that I was confronted by a young fellow about my own height, whose eyes were snapping with excitement. He had the complexion of a rose-tinted peach. And he looked to be not much more than a boy. Before I could get farther

along in looking him over, I heard him say, distinctly and without making a break of any sort:

"You are the Tribune's Mysterious Mr. Sly. Do you deny it?

SLY IN A TIGHT GRIP.

I made no reply but attempted to proceed when his grip tightened and he said:

"You are not going to get away from me this time."

Then he shoved a newspaper up in front of me. I grabbed the paper, making another effort to pass in, but without avail. We were blocking the entrance. The cabman stood behind us holding my bag. Three fellows had run up on the steps and more were crowding about us. One of them had pushed partly between my captor and myself with a paper in his hand, saying: "You are Mr. Sly."

PINK SLIP WORTH $250.

In the meantime I cast a hurried glance over the date on the paper, and saw that it was Thursday morning, Oct. 11. I also observed a pink slip pinned onto the paper. It was worth $250. All of this took only a moment. I was still striving to move on and my captor was holding fast. I had no idea of shaking him. I simply wanted to get through the doors.

SLY ADMITS CAPTURE.

I saw that I was captured according to conditions and said: "Come on." The young man yielded to my command. We pushed through the doors. At the same time I turned to him and in an unimportant way, said:

"You have won the money."

At that time I didn't know what the pink slip meant—six months or one year's subscription; $150 or $250—not having seen one. When we got through the doors, he placed his finger on it and then on examining it I saw that it was a year's subscription to the Tribune.

"What is this?" I asked.

"A year's subscription," he replied, in a tone of triumph.

I turned to him with some astonishment and said: "Young fellow, let me congratulate you. You have won $250."

"Are you really the man?" he asked, looking up with an expression showing some fear lest he was being fooled.

"I am." He made no further remark. I paid the cabman, who had kept close to us, and gave my things to a couple of bell boys, who were pushing through a large crowd that had quickly gathered about us.

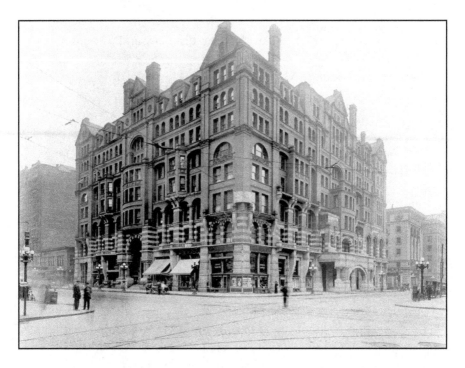

What turned out to be the final clue advised readers that Mr. Sly would be at the West Hotel after 1:00 p.m. on October 11. He found a crowd waiting there, and the game was soon up. *Courtesy Hennepin County Library Special Collections.*

CROWD GREETS SLY AT HOTEL.

No loud remark had been made to indicate who I was. They simply seemed to know. Turning the corner in the cab, I had observed the crowd in both streets. Now it seemed they had poured into the hotel, filling the rotunda.

"What is your name?" I asked my captor. He gave it to me. Then he informed me he was a law student and his home was in Indiana.

"Any relatives living here?" I asked.

"Yes, two brothers, Frank Richardson and G.L., both in Barnaby's at Fourth street and Nicollet avenue."

We had now reached the desk and were pinned in by an immense crowd. The clerks extended a hearty greeting to myself and congratulations to Richardson.

SLY BOUND TO REGISTER.

"I will register as I intended, had I not been caught," I said, and I wrote on the register:

"A.L. Wing, Oshkosh."

"Yes, that is the man," said a fellow at my elbow.

Another pushed up to me as we turned away from the desk, the crowd dropping back and extending a copy of the Tribune, said: "You are the Mysterious Mr. Sly—"

"Hold on," I broke in. "You are too late. This man has me."

Richardson and I, followed by the crowd, went over to the cigar stand. I stepped up to the black-eyed lady behind the news counter and asked her if she remembered me. I had been in there ten days ago.

"I certainly do," she replied, laughingly. "You wouldn't have got away from me again."

After getting a luncheon at the hotel café and phoning to the office, although a Tribune reporter was at the desk as soon as we were and got the information, I invited Mr. Richardson to go along and get his money. At the approach to the Tribune and in the halls we found other crowds awaiting us.

Mr. Richardson was congratulated by the Tribune management when he was handed a check for $250.

WAS A PERSISTENT SLEUTH.

"I have been following you up for six days," he said to me. "I have held up nine people in that time. I have even sometimes neglected my classes, and my brothers laughed at me. Twice I tackled Thomas Hickey, ex-president of the American Baseball association. Do you know what picture caught you?" he said, showing me a blank book in which he had pasted every picture of the Mysterious Mr. Sly that had been published. "That is the one," and he pointed out the front view print of myself with smooth face and wearing a derby hat.

WHERE THE MONEY WILL GO.

"What will you do with the money?" I asked.

"I will use it to help pay the balance of my schooling. I will take a trip with the football team to Chicago and defray the expenses of a visit home."

"Did you see me when I was at the university?" I asked.

"No, I was in my class."

Then he continued: "I made a study of your pictures and watched closely your movements as you described them. Last Saturday I got a receipt for six months' subscription to the Tribune. Then, on Monday, I increased it to a year. I said that I might as well get the whole thing; besides, if I did not succeed I would have the paper paid for and would be no money out."

Mr. Richardson received numerous congratulations on the streets and at the Tribune office. A great many people we met on our way to the Tribune

told me that the money went all right. It could not have gone to a better party—a young man paying his way through school; one more deserving of it.

It was a big disappointment for me because I was in the hopes I would get through this seventeenth day which is the best I have previously done, and break my record, even if only for one day. But my pictures had given me away.

A Nun Kidnapped

JUNE 8, 1907, *MINNEAPOLIS TRIBUNE*

This fascinating tale appeared on page one of the Tribune. *The article provides all the clues you'll need to figure out who committed a daring crime. Or you can skip straight to the end to learn what prompted the strange kidnapping of Sister Borromeo, née Emily (Minnie) Digle. The original misspellings of her name are preserved.*

ABDUCTED
SISTER IS KIDNAPED FROM PAROCHIAL SCHOOLROOM AT DULUTH.

TWO MEN SPIRIT WOMAN FROM SCENE
DARING CRIME COMMITTED BEFORE PUPILS—POLICE NOW SEARCHING.

VICTIM'S PARENTS RESIDE IN ST. PAUL
FATHER OPPOSED DAUGHTER TAKING VEIL—IS NOW OUT OF CITY.

DULUTH, Minn., June 8. (Special)—Sister Borromea of St. Clement's Catholic school was kidnaped yesterday by two men who have disappeared, leaving no trace of themselves or their victim. The outrage was one of the most daring ever enacted in Minnesota.

TWO MEN ENTER.
The sister was teaching in the primary room at 1:30 in the afternoon, when the two men entered, seized and carried her half a block to a hack, thrust her in and dashed away.

St. Clement's Church and School and St. Mary's Hospital in Duluth in about 1890. *Courtesy St. John's Abbey Archives.*

Her young pupils were spellbound with terror and stood mute for several seconds, but when the sister was being borne screaming to the street, they regained their senses and raised an outcry which alarmed the entire neighborhood.

The police were notified and every officer in the city was warned to look for the kidnapers. A special detail of six men was also put on the case, but no trace of the sister or her assailants has been found up to midnight.

It is believed that they are still in the city or the country nearby.

The abducted woman is 24 years old and is the daughter of Edward Deigle, superintendent of the St. Paul terminal railroad yards. He is a non-Catholic and has opposed his daughter taking the veil.

She was to make the final vow, binding her for life, July 11.

The screams and entreaties of the nun as she was carried bodily into the street by her abductors attracted several hundred students of the school and persons in the neighborhood, and before the carriage was half a block away a howling mob was in pursuit. They were soon distanced, however, and abandoning the chase they turned to the police for aid.

SITTING AT DESK.

The abduction was marked with a degree of desperation and boldness seldom equaled. Sister Borromea was sitting at her desk when two men entered, and advanced toward her at a rapid pace.

Abductors Boldly Enter Room Where Sister Borromea Is Teaching and Carry Her Away.

PUPILS SPELLBOUND BY TERROR

They Stand Mute While Abductors Drag Shrieking Woman to the Street and Thrust Her Into Hack, But Recover in Time to Give Chase—Are Joined by Hundreds of People in the Neighborhood, But the Team Is Fast and Outfoots Them—No Clue to Where the Outlaws Have Secreted Their Victim—Relatives of the Sister, Who Is a Daughter of Edward Digle, Formerly of Itasca, Are Suspected of Being Responsible for the Desperate Act.

Duluth News Tribune headlines painted dramatic images of the abduction. According to later newspaper accounts, though, Digle hadn't made much of a fuss during her removal, and no mob chased the hack.

As they approached her the sister bowed courteously and called the heavier of the two "Father" in her salutation.

Without a moment's warning they seized the teacher, one taking her by her arms and the other by her lower limbs and carried her to the door. The sister screamed and fought desperately, but she was powerless in the hands of her abductors.

Without once pausing they bore her to the street and thrust her into a hack.

DEIGLES AWAY.

Little could be learned last night regarding the Deigle family, and the abduction of the daughter in Duluth. Mr. Deigle just recently took charge of the terminals in St. Paul. The family, which at present consists of only man and wife, lives at North St. Paul. The father could not be reached by telephone last night, and neighbors said that he and his wife had gone away on a fishing trip.

FOLLOW-UP: The next day, the Tribune *reported that Sister Borromeo's father, a Protestant, had kidnapped her to return her to the family and prevent her from taking her final vows that summer. "We did what we thought was best," he said. His daughter*

Mother Scholastica Kerst, prioress of St. Scholastica Monastery, exchanged several letters with Minnie Digle after her abduction. *Copyright © St. Scholastica Monastery.*

was reported to be calm about the abduction but insisted that she would return to the convent "as soon as I get a chance."

I contacted Sister Margaret Clarke, archivist at St. Scholastica Monastery in Duluth, for background on the case. She kindly forwarded copies of newspaper clippings and correspondence from the period, including heart-wrenching exchanges between Mother Scholastica and Sister Borromeo.

"I am fully convinced that you have a vocation, and a good one, so is every body else that knows you; and we do sincerely hope and pray that our dear Lord will give you courage to persevere, and not look back at the 'flesh-pots of Egypt,'" wrote the prioress in a letter dated June 11, 1907.

"Oh Mother such agony I am going through…I am the most unhappy creature on earth," Sister Borromeo said in a handwritten letter dated June 18. With the help of supporters, including St. Paul's chief of police, the kidnapped nun returned to the monastery in late June and made her final vows on July 11, the Feast of St. Benedict.

But that's not the end of the story. The following July, Sister Borromeo left the motherhouse again, "without any warning whatever, and is likely gone to her people," Mother Scholastica explained in a letter to the bishop of the Duluth diocese. "Whatever did not suit her I cannot tell; everybody was always kind to her and made a good deal of allowance, though she often proved rather frivolous."

Sixteen years later, a contrite Minnie Digle wrote to the monastery's new prioress, Mother Agnes Somers, seeking "readmission to the Benedictine order and your community." She admitted fault in leaving the community in 1908, attributing it to "a fit of temper" and a misunderstanding with Mother Scholastica. She also wished to put to rest rumors that she had cooperated in the 1907 kidnapping, saying that she would be willing to take an oath that she was not responsible in any way and "resisted as far as it lay in my power."

Mother Agnes put the matter to a vote of the community. Those opposing Digle's return carried the day, eighty-three to forty-one.

Pax +. St Paul Minn,
 June. 21, 1907.

My dearest Mother:—
 Do you know where
I am, I ran away from home
this morning, and went to the
detectaves home, and stayed there
all day and they brought me
in disguise to Sister Helen's sisters
home and here I am safe and
sound and will be with you soon
I got your letter yesterday and I
made up my mind right away
to go the first chance I got.
Oh I am so happy if I only
get to you safe now. Mother I
am going to wait for your

A portion of a letter from Sister Borromeo to Mother Scholastica, June 1907.

The prioress explained the decision in a letter to the Duluth bishop dated June 24, 1924: "I was not familiar with Miss Digle's history and I was astonished at the amount of opposition that was shown, but I was even more astonished at the reasons for it. The Sisters, and most of them the older ones, were almost unanimous in saying that Miss Digle was fickle, untruthful and given to spectacular conduct, and that they doubted her sincerity now."

Mother Agnes broke the bad news in a brief, typewritten note:

Dear Miss Digle:

As I promised you I have laid your request before the Sisters and though the Sisters sympathize with you in your desire to return to our community it is the opinion of the large majority that your re-entrance here is not for your own happiness nor for the best interests of our community.

The sisters suggest that you enter some other Benedictine convent where the regretful past is not so well known, and I personally am most willing to help you if you decide to do so.

With sincere good wishes from all the Sisters, I am

Yours very sincerely in Christ,
M. Agnes

Details of Minnie Digle's post-monastic life are sparse. Census records indicate that she settled in Superior, Wisconsin, where she worked as a bank clerk for many years. She died in 1963 and is buried at Forest Hill Cemetery in Eau Claire.

A Sea Lion Escapes

JUNE 10, 1907, MINNEAPOLIS TRIBUNE

*S*ome older readers may have childhood memories of Longfellow Gardens, a zoo adjacent to Minnehaha Falls. It opened in 1907 and attracted thousands of visitors each year before closing in 1934.

At its peak, the Minneapolis zoo boasted a variety of animals: hippos, zebras, camels, elephants and, of course, lions and tigers and bears. Most were kept in small pens, pits or cages, but deer, elk, flamingos and sea lions were allowed to roam the grounds, at least in the early years.

In 1907, one sea lion decided that he'd had enough of the place and found a way out. The Tribune took a fanciful approach to Paupukeewis's escape, with reports suggesting that the animal "flip-flopped" over Minnehaha Falls and made his way down the Mississippi River, stopping briefly at a houseboat in "Lillydale" on his way south in search of "sunny climes."

In this initial report, the Tribune informed readers that the escapee "wore a plain suit of shiny black" and answered readily to the name of Paupukeewis. The clever mammal proved elusive. Despite numerous sightings in the days that followed, Paupukeewis was never recaptured.

ROARING SEA LION IS ROLLING ALONG TO SUNNY CLIMES

Paupukeewis, the sea lion which R.F. Jones thought was tame enough to stand without being hitched, has neglected to wire its master since it left its beautiful suburban home in Longfellow Gardens and went splashing down the Mississippi. Thinking it might have decided to spend a few days at

Wearing his trademark top hat, zoo founder and owner Robert (Fish) Jones fed some of the sea lions that still roamed the grounds of Longfellow Gardens in about 1910. *Courtesy Minnesota Historical Society.*

that delightful down-the-river bathing place, Harriet Island, Mr. Jones has forwarded its description that it may be apprehended, but thus far no one seems to have seen the animal there.

Mr. Jones is afraid Paupukeewis is intending to make his way to the gulf and then wait around until the completion of the Panama canal, when it will cross to the Pacific to visit relatives at its former home, Santa Barbara, Cal.

The sea lion is said to have made a friendly overture to one John Knutson, a sorter on the St. Paul boom, to the extent of biting a piece out of his trousers and to have paddled away with the sample. Another report of the missing animal described him loitering lazily at the mouth of the Minnesota river, but plain-clothes men sent out from Longfellow Gardens failed to locate Paupukeewis.

The zoo near Minnehaha Falls attracted thousands of visitors every year before it closed in 1937. *Courtesy Library of Congress.*

Mr. Jones is afraid the animal will be the target of some sportsman who will mistake him for a great river monster, and to hasten the return of the pet he has offered rewards.

When it left home the sea lion wore a plain suit of shiny black, and it answers readily to the name of Paupukeewis.

A Baffling Gender Switch

JULY 11, 1907, MINNEAPOLIS TRIBUNE

*T*his century-old mystery remains unsolved—unless you count the fanciful and self-serving explanation that appeared in the Tribune over the following two days.

BAFFLING MYSTERY CAUSES COMMOTION
UGLY MAN TRANSFORMED INTO HANDSOME WOMAN.
"WAS IT A DREAM?" ASKS HACK DRIVER, SORELY PUZZLED.
ANOTHER PAWN ENTERS INTO GAME IN SHAPE OF STRANGER WHO DISAPPEARS.

The "Mystery of the Hack, or, How Bold is Ann," is the appropriate title of a strange story dealing with the experiences of two most unusual individuals in Minneapolis early Tuesday evening.

Who they were, where they were going, what crime they had committed, how long they have been crazy and what became of them are questions that remain unanswered.

It was several minutes after 7 o'clock when a very ordinary appearing man approached Wilman Franzo, a hack driver at the West hotel, and asked to be driven rapidly to the Milwaukee depot. The next train out was the Pioneer Limited and the cabbie couldn't see just why he should tire his horses when there was plenty of time to catch the train. Nevertheless, he hustled along, and arriving at the station, jumped down and opened the door of his vehicle, and was astonished to see a smartly dressed young woman step out.

The Milwaukee Road Depot in Minneapolis in about 1901. Which "toilet room" did the passenger slip into—men's or women's? *Courtesy Hennepin County Library Special Collections.*

SMILES SWEETLY.

She was the sole occupant of the cab. She gave the hackman a sweet smile and a $1 bill, and then disappeared into the depot toilet room. So astonished and bewildered was the hackman that he lighted a match to be sure that the man he had seen enter was not hiding under the seat. Nothing of an unusual nature was found inside the vehicle.

Greatly mystified, he slowly returned to his stand at the hotel, still positive, however, that it was a man whom he had picked up and as he had made no other stop, his deduction was that Mr. Plainlooking Man had changed himself into Miss Charming Woman.

At the hotel he was still further perturbed to learn that Carriage Agent George W. Shipton had just been approached by a peculiar looking black whiskered, nervous individual who wanted to know if a certain woman had

taken a hack. He then proceeded to describe the woman whom the hack driver had left at the Milwaukee depot.

She was good looking; had auburn hair; her gown was well tailored, of a fluffy leather colored material. She wore long gloves and a sailor hat with green parrot colored feathers, which was draped with an automobile veil.

MAN HURRIES AWAY.

The man who inquired about her, upon receiving an unfavorable reply from the carriage agent, approached Chief Clerk Conry, who, of course, was likewise unable to give the desired information. The man then wanted to know what time the next train left on the Minneapolis and St. Louis road, and being told that it left at 3 o'clock made a hurried exit, and was not again seen.

Whether or not the uncanny passenger whom he handed into his hack carried a grip or not, the hackman is unable to say. He is under the impression that there was a grip, but he does not remember having handled it. If there was no grip, how the man disguised himself as a woman added to the already complicated episode.

Whether the person in the hack and the man, who later called, were partners in crime no one can say. One Sherlock Holmes, more brave than the rest, has it figured out that the person who got into the hack was really a man and that he changed his clothing on the way to the depot to escape detection while on board the train. The second man is thought to have missed his appointment with his pal, thus accounting for his nervous haste.

At any rate, the mystery remains as baffling as ever, and the more the hackman thinks about it the more troubled are his dreams.

The next day, with no fact-based explanation in reach, the Tribune *identified the cab passenger as the fictional newspaper heroine "Fluffy Ruffles," an attractive and well-attired young woman who couldn't hold a job because she was such a distraction to men.*

HACK MYSTERY IS SOLVED; IT WAS FLUFFY RUFFLES?

The strange young woman who shocked a hackman by stepping from his vehicle at the Milwaukee depot Tuesday evening, when the driver believed he had a man, was probably Fluffy Ruffles, the stunning young woman whose marvelous feats have been watched with absorbing interest by readers of The Tribune.

Of course, there is no proof that it was really Fluffy, but it is known that the young woman contemplated taking a run out in the country for a breath

Fall Hats in Becoming Modes

FEW read fashion alike. What one admires another may not fancy. That which is most becoming to you, may not be individually charming to others. Our wide assortments permit of exact choosing from the season's preferred styles.

For Saturday's shopping we present a "just received" group of trimmed hats, in some very pleasing models. The prices range

$2.50 $3.50 $4.50
$6.50 $7.50

Ostrich Plume Hats at $10

All the newest shapes are represented in this group of hats and the preferred colors are shown in navy, brown and black. We shall not attempt to give detailed descriptions of these numbers. You will find them remarkably good values at. **$10**

VELVET MORNING GLORIES—
The new flowers so much in vogue just now. 75c grades
Saturday**49c**

Featuring Some New Headwear

LARGE ROSES of silk and velvet, with foliage, five popular shades. Regular at 75c, Saturday......**49c**

FEATHER POM PONS—white fluffy kind, wired and almost indestructible—Saturday at..........**25c**

FANCY WINGS—A variety of colors, including navy, brown, black and white. 69c value at...**25c**

New silk shapes at 98c.
New felt shapes at $1.49.
Silk-velvet shapes at $2.49.
Include all the newest styles and favored colors.

Fluffy Ruffles, the stylish and indefatigable creation of Carolyn Wells and Wallace Morgan for the *New York Herald*, inspired a Broadway hit, a line of paper dolls and untold numbers of hats like this, shown in a Dayton's ad in September 1907. *From* Tribune *microfilm.*

of fresh air, and with her magical accomplishments she could easily have deceived the hackman.

If, however, it was not Miss Ruffles, the mystery is as deep as ever, for nothing more has been heard of the principals in the strange episode.

On July 13, the Tribune *took the joke a step further, quoting the indefatigable Miss Ruffles in a story that listed the uncanny likenesses between the comic strip character and the gender-switching passenger.*

DID IT WITH MY SMILE
REALLY NO CAB MYSTERY—FLUFFY RUFFLES ADMITS.
DEDUCTIONS OF AMATEUR SLEUTHS ARE SPOILED WHEN PRETTY SUNDAY
TRIBUNE HEROINE BLUSHES WHEN ASKED POINT BLANK IF SHE IS THE
"GUILTY PARTY."

Fluffy Ruffles admits having taken the ride and the mystery of the hack is cleared.

Minneapolis evening newspaper of Wednesday told how a man got into a vehicle at the West hotel corner and when what was apparently

the same person got out at the Milwaukee depot, it was a pretty young woman.

To add to the tangle an excited individual rushed up to the carriage agent shortly after the hack had gone and wanted to know if a young woman had been there and then described the young woman who got out at the station.

Since then there has been frantic efforts by "near" detectives and other amateur sleuths to solve the problem, but only The Tribune has made the proper deductions.

First—It was reasoned that whoever did the transformation stunt must have been an unusually clever woman.

Notation number one, in favor of Fluffy.

Second—The strange passenger smiled sweetly and gave the driver a dollar bill, with one corner missing.

Fluffy always smiles, and to know the money if she ever sees it again cuts the corners off her bills.

Third—The individual who chartered the cab was possessed of a rare power, pleasing, it is true, but none the less effective, by which she made the open-mouthed hack driver imagine she was a man. Fluffy Ruffles again.

Fourth—The excited man who inquired after the young woman had a milk pan which he wished converted to a Paris hat. It was easy to deduct that he was after The Tribune's heroine, Fluffy Ruffles.

When point blank accused of the little escapades yesterday, Fluffy blushed prettily. "I did it with my little smile," was all that she would say.

"Psychic Wonder"
Astonishes Minneapolis

JANUARY 14, 1909, MINNEAPOLIS MORNING TRIBUNE

A "Russian psychic" in town for a show at the Bijou Theater promised Minneapolitans an audacious public demonstration of mind-reading. John Neuman, the Tribune *reported, would find "an article hidden by a committee of five men, chosen by The* Tribune, *the article itself being absolutely unknown to Neuman." But wait, there's more: "He will drive blindfolded through the streets of Minneapolis and drive to the place where the article is hidden. Neuman will not only find the article, he says, but will perform the unusual 'stunt' of driving a pair of horses through the streets strange to him with his eyes covered…He announces that he will not fail in locating the hidden article, whether it be a toothpick or a dry goods box."*

A large crowd gathered outside the Tribune *building at 3:00 p.m. on January 13, 1909, to watch the spectacle play out. Readers who picked up the paper the next day didn't have to read far to see whether Neuman succeeded.*

NEUMAN, THE "PSYCHIC WONDER," FINDS HIDDEN KEY; COMMITTEE MEMBERS CALL IT "MUSCLE READING"
DRIVES BLINDFOLDED THROUGH STREETS.
GOES TO DRUG STORE AT NICOLLET AND LAKE, WHERE QUEST ENDS.
WITNESSES CREDIT THE RUSSIAN WITH A CLEVER PERFORMANCE.

Following a blind drive through Nicollet avenue yesterday afternoon, Prof. John Neuman, "the psychic wonder," found a key hidden in a safe at Goodrich & Jennings' drug store, 2 E. Lake street, yesterday afternoon.

An immense crowd waited in front of The Tribune office and saw Neuman drive away, blindfolded. A number followed in automobiles, and

Spoiler alert: Professor John Neuman may have been psychic, but he was neither a professor nor a Russian. And his real name was Christian A. Newmann. *Courtesy Library of Congress.*

when the hidden article was picked from beneath a pile of envelopes the crowd cheered enthusiastically.

Professor Neuman naturally claims that the key was found through reading the minds of the committee, but of the six members of the committee the majority credit "the psychic wonder" with nothing more remarkable than a clever sense of muscle reading.

All admit, however, that Professor Neuman is very clever, and that as he delivered the goods, he is deserving of all credit.

The committee was composed of J.B. Miner, professor of psychology at the University of Minnesota; Rev. J.S. Montgomery, pastor of Fowler M.E. church; Dr. Charles A. Erdmann; W.W. Heffelfinger, Frank T. Corriston, superintendent of police, and James F. Ellis.

TOOK OVER AN HOUR.

It took Professor Neuman 1 hour and 15 minutes to announce himself victorious. For a while a burglar proof safe balked him, but after working the combination he rushed along to victory, and afterwards announced that the committee had given him the hardest test of his career. This view is indorsed by members of the committee.

A curious crowd began arriving in front of The Tribune building at 2:30 o'clock. A few minutes later Professor Neuman arrived and met the committee in the reception room.

He said that Northwestern and Twin Cities telephone directories were necessary to the mind reading stunt and these were produced. Four members of the committee—Rev. Mr. Montgomery, Dr. Erdmann, Professor Miner and Mr. Ellis—were sent out in an automobile to hide the article.

It was explained to them that if the article was hidden where there was a telephone, that the number of the phone, the name of the subscriber and the address must be committed to memory. In case there wasn't a phone at the hiding place, the committee was told to leave the number, name and location of the nearest phone.

PROFESSOR BLINDFOLDED.
When the hiding committee returned to The Tribune office Professor Neuman closeted himself with them. All others were excluded.

The professor was blindfolded. "Is the name in this book?" he asked, picking up a Twin City directory.

The committee admitted that it was. Taking Rev. Mr. Montgomery by the hand, Professor Neuman slowly turned over the pages of the directory with his free hand.

"The name of the place where the articles is hidden is on this page," Neuman announced when he had reached page 46.

Still holding Rev. Mr. Montgomery by the wrist, the professor took a pin in his hand and slowly ran it down the page. The committee stood around expectantly.

When the pin point reached the name, "Goodrich & Jennings," it hesitated and then was stuck in the paper. It is the general [opinion] of members of the committee that the involuntary movement of Rev. Mr. Montgomery's muscles gave Professor Neuman his cue and enabled him to pick out the right name. The experiment was tried on Mr. Ellis and the pin stuck in the same identical hole.

BEGINS HIS DRIVE.
Professor Neuman was then led to his carriage in front of the Tribune, and with 5,000 persons looking on began his blind drive on Nicollet avenue. The carriage was obtained from the Minneapolis Livery company. N.M. Kayler, the driver, occupied the seat beside Neuman.

Picking his way through the crowd, Neuman turned west on Nicollet avenue and drove along at a brisk gait. The sight of a blindfolded man

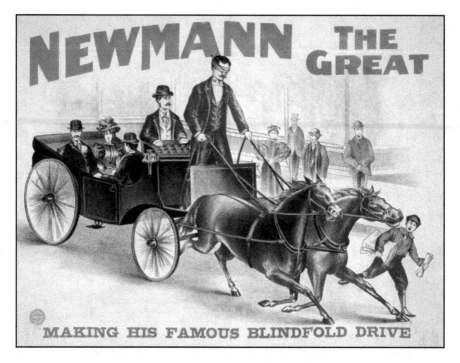

NEWMANN THE GREAT

MAKING HIS FAMOUS BLINDFOLD DRIVE

Early in his career, Newmann perfected the "blindfold ride," an illusion in which a blindfolded performer guides a vehicle through unfamiliar streets.

driving through a crowded street was one of the spectacular features of the performance.

Professor Neuman turned down Twelfth street and proceeded to Clinton avenue and thence to Lake street. At Lake street Neuman alighted and groped around, apparently hunting for a scent. After a few moments he climbed to the seat again and drove on Lake street to Nicollet avenue. Here Neuman, followed by the committee and a large crowd, entered the drug store of Goodrich & Jennings.

He groped around the store for a few minutes and then walked behind the counter. Finally the "psychic wonder" centered his attention on a pile of papers and books in one corner of the room. In a moment the professor had discovered the safe beneath the papers and thereafter he never left it until the missing key was produced.

Guesses Combination.

"Will someone open this safe?" asked Neuman.

"We'll get the proprietor and you can read his mind and get the combination," said a member of the committee.

Neuman objected to this at first, but later agreed and with Dr. James Crew, a member of the firm, holding his hand, began turning the combination.

Neuman was not successful in his attempt to work the combination and professed to be angry that two tests should be given him, those of finding the missing article and working the combination of a safe.

"Give me a piece of paper, and I'll write the combination and you can open the safe," he said after a while and the members of the committee agreed.

The figures "90" were traced slowly out by the blindfolded mind reader and the committee members showed their astonishment. The first number of the combination was 90. The second number was also given and after the third number had been given partially, the safe was opened.

Neuman Puzzled.

The professor was undoubtedly looking for a strange article and when he found a small pair of tweezers he had a great deal of trouble in deciding whether he had the article.

Personal contact was resorted to again. Holding Rev. Mr. Montgomery by the hand he asked him to think whether the tweezers were the missing article. The pastor of the Fowler M.E. church must have thought right, for the "wonder" gave the tweezers up as a bad bet and after a short time fished the key from beneath a pile of envelopes and proclaimed it the article which had been hidden. He was right.

The key had been furnished by Rev. Mr. Montgomery and is to one of the front doors of Fowler church.

"The committee gave me the hardest test of my career," said Professor Neuman after the key had been found. "Minneapolis is worse than Boston. I want to say since it is all over that there was no trick or collusion. I found the key by reading the minds of members of the committee."

The members of the committee were surprised at the success of Professor Neuman. While none would admit that he thought him a mind reader, they all admitted the cleverness of the performance and congratulated him on finding the hidden key.

NOT CONVINCED.

Professor Miner made the following statement last night: "I am ready to be convinced that there is such a thing as telepathy, but I am not convinced by the work of Neuman today.

"I think that a purse of several hundred dollars should be made for the person who successfully demonstrates telepathy under scientific conditions."

Dr. Montgomery said: "Professor Neuman surely performed a clever stunt. Everything was done in the open and on the square. Whether it was muscle reading or mental telepathy, I know not. However, he found the key and is entitled to great credit for his piece of work."

"It was an exhibition of straight muscle sense reading

Another spoiler alert: "Professor Neuman" was probably quite familiar with the streets of Minneapolis, including Nicollet Avenue, shown here in 1908. *Courtesy Hennepin County Library Special Collections.*

and nothing more," said Dr. Erdmann. "It was in no sense telepathy, and so far as being a muscle-reader is concerned, there are many in the business who are the superior of Professor Neuman in my opinion."

Professor Miner explains Professor Neuman's performance in this manner: "The page of the telephone directory and the number on the page were made known by involuntary muscular movement on the part of Rev. Mr. Montgomery. The professor was able to see under the bandage and read the address on Lake street. His superficial knowledge of the city enable him to drive there.

"When Neuman reached Lake street on Clinton avenue he was not sure which way to go. His wanderings in that vicinity were to enable him to find which way the numbers ran and after doing this he drove in the proper direction. His location of the hidden key in the drug store was worked out by native cleverness and muscle-reading."

Professor Neuman is filling an engagement at the Bijou theater. He will appear there tonight, Friday and Saturday.

Members of The Tribune staff followed the professor in his drive with J.C. Jordan in his seven-passenger Franklin and Fred Starr's 40-horsepower Pierce-Racine.

FOLLOW-UP: The "Russian psychic" was really Christian A. Newmann of Kenyon, Minnesota, a small town about sixty miles south of the Twin Cities. In the early 1900s, he toured the Upper Midwest as "Newmann the Great," performing mind reading and hypnotism stunts. A friend, famed magician Howard Thurston, declared him to be the greatest mentalist of his time. In his later years, Newmann demonstrated hypnotism at university psychology classes in Minnesota and North Dakota. He died in Minneapolis on December 29, 1952.

Last Red Squirrel Haunts Loring Park

APRIL 27, 1909, MINNEAPOLIS TRIBUNE

*T*heodore Wirth had a soft spot for Minneapolis songbirds. The city's orioles, larks and sparrows were under siege when Wirth took office as parks superintendent in 1906. Public enemy no. 1? "Boys who rob birds' nests," according to the Minneapolis Tribune. In March 1909, he ordered park police to enforce an ordinance that prohibited boys from bringing guns into city parks.

The birds had a few four-legged enemies as well. About a dozen chattering red squirrels had the run of Loring Park, destroying eggs and young birds in the nest. Wirth instructed his officers to shoot the reds. To prevent neighboring reds from repopulating the park, he shipped in gray squirrels from Wichita, Kansas. "Gray squirrels," the Tribune explained, "are preferred in parks all over the country because they are easily tamed and do not interfere with birds at all."

One month later, the newspaper reported, only one red squirrel remained in Loring Park.

LAST OF THE "REDS" HAUNTS LORING PARK
GRAYS COMING FROM KANSAS TO TAKE THE CHARMED LIFE OF "CRUNCHO."
WILY BIRD-EATING QUADRUPED SUCCESSFULLY DODGES COPPERS' BULLETS.

"Cruncho the Red," the last of the squirrel hordes in Loring park, a defiant rebel, who is apparently bullet-proof, or at least possessor of a charmed life, roams at will through the park and chatters out a saucy defiance at Theodore Wirth, whenever he happens along. However, Cruncho has but another month in which to give up the battle and die game, or put pride behind him and hike to Kenwood parkway, where many of his relatives have flown, as persecuted patriots fleeing to a land of freedom.

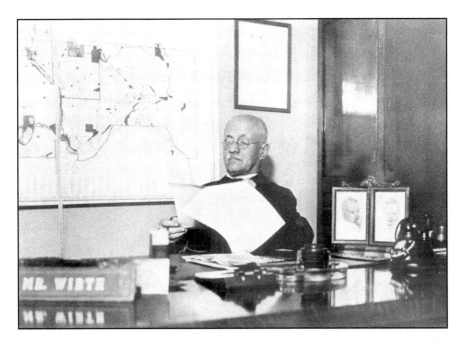

Minneapolis parks commissioner Theodore Wirth at his desk. *Courtesy Hennepin County Library Special Collections.*

Red squirrels had the run of Loring Park in 1901. *Courtesy Hennepin County Library Special Collections.*

In one month's time Mr. Wirth expects to receive from Washington state a consignment of two dozen gray squirrels, which are to be installed in some newly built, just-for-two cottages, in the trees of Loring. Mr. Wirth had expected ere this to have the gray squirrels here but was disappointed.

Meanwhile "Cruncho, the Red," he of the hated family of bird-eating squirrels, grinned sardonically at the superintendent of parks yesterday and dodged a volley of bullets from the revolver of the park policeman.

Quickest Adoption on Record

SEPTEMBER 26, 1909, *MINNEAPOLIS TRIBUNE*

Want to adopt a baby? In 1909, you could wait for someone to drop a foundling on your doorstep. Or you could visit the nearest orphanage, fill out a lot of paperwork and wait your turn for one of the babies there. One Minneapolis woman didn't have time for all that. She stopped by the Tribune *offices on a Saturday morning and asked the city editor for help. Four hours later, she was on her way home with a little boy in her arms.*

Tribune Finds Baby for Childless Home
Sends Reporter to the Jean Martin Brown Home to Secure Birthday Gift.
Mrs. R.D. Ousley Selects Tot and Carries Him Away to Present to Husband.
Neighbors Will Hold Welcome Party in Home Now Made Complete.

"She came, she saw, she took away," is the brief history of the quickest adoption on record.

Mrs. R.D. Ousley, 1619 Girard avenue north, came to The Tribune office at 10:30 o'clock yesterday morning [a Saturday] to ask for aid in finding a baby for adoption that very day, so she might surprise her husband on his birthday today. In just four hours and five minutes, she was holding in her arms a dear little baby boy.

Under guidance of a Tribune reporter the necessary certificates were obtained and filled out, and then Mrs. Ousley was led into the nursery of the Jean Martin Brown home, 2239 Commonwealth avenue, where 21 tiny bits of humanity lay in their white cribs and cooed and cried a bit and doubled up their little fists.

Mrs. Ousley looked long at each one and finally chose a little 7-month-old boy, with big gray eyes and light hair with a glint of gold, and a little half shy smile. Mrs. Ousley took the little chap home with her, only stopping to have his picture taken.

HOME WAS INCOMPLETE.

Mr. and Mrs. Ousley have a pretty home on Girard avenue north, nicely furnished in every detail and built only four years ago. Mr. Ousley is a waiter at the West hotel, where he has been employed 20 years. He and his wife have prospered, but the pretty home was lonely for there was no little child to pet and love and fuss over. Three canary birds and a Spitz dog made up the household. But a fluffy white dog, no matter how affectionate and intelligent he may be, and three little songsters, no matter how gayly they may sing, are at best poor substitutes for a real, live baby, and Mr. and Mrs. Ousley had often expressed the wish in the last two years to adopt a little one for their own.

Last Sunday Mrs. Ousley saw the picture of little Dollie, who was left with Mrs. Weese on the East side, and who needed a home as Mrs. Weese was about to move out West. Mrs. Ousley went to see the baby on Monday, but found to her disappointment that there had already been scores of people eager to make the happy youngster theirs, and Dollie had found a good home.

Mrs. Ousley looked all week for a baby, for today is her husband's birthday, and what would be more delightful than to give him a dear little baby for a birthday present? She was unsuccessful, however, and Saturday morning she came to The Tribune office.

COULD NOT FIND BABY.

"I can't find a baby anywhere," she said to the city editor in despair. "Can you help me out?"

The man behind the desk didn't know. He called up the Jean Martin Brown home.

"Have you a baby for adoption today?"

"Yes, we have babies but not for adoption today," was the reply from the matron. "There are reference blanks to be filled out and many inquiries to make first."

Then the services of the reporter were called in. She went first to the Children's home in St. Anthony Park and was given the reference blanks with instructions as to the proper method of filling them out. The next move was to go to the North Side and have the blanks filled out by three of Mrs. Ousley's neighbors, Mrs. Strike, 1621 Girard avenue north; Mrs.

Mrs. Richard Ousley and little Richard posed for a *Tribune* photographer moments after she selected the wee lad from among twenty-one orphans at the Jean Martin Brown Home in St. Anthony Park. *From the* Minneapolis Tribune.

Michael Sullivan, 1615 Girard avenue north, and Mrs. Michael Hoban, 1827 Girard avenue north. Then the reporter, accompanied by Mrs. Ousley, took the long ride to the Children's home where, the references proving satisfactory, the prospective mother was shown a roomful of babies from which to choose.

BABY WILL RULE NEIGHBORHOOD.

According to custom at the Jean Martin Brown home, the baby will be taken on a three months' trial, but Mrs. Ousley says he is as good as adopted now.

Master Ousley will receive a hearty welcome into his new home for today he is to be the honor[ed] guest at a party of 20 friends who have been invited to celebrate Mr. Ousley's birthday. The neighbors are all much interested in the new baby as Mrs. Ousley has told them that she hoped to adopt one soon. A neighborhood "baby shower" is to be the next event at which Master Ousley will be the center of attraction.

The lucky little lad will be monarch of all he surveys and there will be a fluffy white dog and three canary birds on Girard avenue with their noses out of joint.

Two days later, the Tribune *reported what happened when Mr. Ousley came home that Saturday night:*

Ousley Family Is Happy with a Baby in Cradle
A Christening and a Shower Next for Little Richard.
Adopted Son Satisfied in Home of His Foster Parents.

When Richard D. Ousley left his home, 1619 Girard avenue north, Saturday morning, the household consisted only of his wife, the white Spitz dog, Dollie, and three canary birds. When he returned home in the evening about 9 o'clock, he found his wife in a rocking chair, holding a little white bundle.

"Your birthday present," said Mrs. Ousley, disclosing something that wriggled and cooed.

"Why it's a baby!" exclaimed Mr. Ousley. "Whose is it?"

"It's ours now," replied Mrs. Ousley. "We have wanted one for so long, so today I went to The Tribune and they helped me get this little fellow from the Jean Brown Martin home."

Master Ousley, hearing himself referred to, stretched out his tiny hand and gave a dear little smile which made a complete conquest of his new father's heart.

Sunday was Mr. Ousley's birthday, and what was the surprise of the 35 guests invited to celebrate the occasion, when they saw another guest of honor—a little chap of only 7 months who looked about him with friendly wide open eyes! One would never guess that it was his social debut, for he took it all with the calm demeanor and excellent behavior of an old hand.

"He never cries," said Mrs. Ousley proudly. "I never saw such a good baby."

He is to be called Richard, and his christening is to be a pretty event of the near future. A friend of Mrs. Ousley, Mrs. Frank Smith, is to have her baby baptized at the same time, and the double christening will take place at the German Lutheran church.

Richard and Dollie, the dog, have grown to be good friends and the canary birds sing their prettiest for the little one who blinks solemnly at them.

Master Dick has already entered on a career of popularity. Since his coming was unexpected, Mrs. Ousley had no opportunity to provide a "trousseau," but little will he miss it, for this week the neighbors are to have a "baby shower" for him, when every possible article he could need or desire will be made and given by willing hands. Already he has a number of baby clothes, given by Mrs. Frank Smith, whose baby is about the same age.

Mrs. Michael Sullivan, a next door neighbor, gave him a pretty white astrakhan coat and Mrs. Strike, the neighbor on the other side, brought over an old German cradle in which she had rocked all of her children, the oldest

of whom is now a young man. The cradle was made in Germany and will be handed down to the first child of Mrs. Strike's eldest son.

Even the little pillow that has seen long service in the cradle is now the resting place of Master Richard's head.

FOLLOW-UP: What happened to little Richard? Research suggests that Richard Earl Ousley, born in Ramsey County on February 18, 1909, led a full life. He served in the U.S. Army during World War II, married a woman named Elsie, had a stepson and lived in Las Vegas for a time. He died in the Twin Cities on August 29, 1978, and is buried at Fort Snelling National Cemetery, as is Elsie. That leaves so many questions: Where did Richard go to school? What did he do for a living? Did he know about the circumstances of his birth and adoption? So far I have been unable to find a living blood relative who can fill in the details. "They're all gone," a step-granddaughter told me in August 2013.

Spanish Fraud Letters Flood State

FEBRUARY 13, 1910, *MINNEAPOLIS TRIBUNE*

*D*ear reader, I trust you will treat this Tribune *report with the utmost discretion. A full century before you deleted the latest Nigerian e-mail scam to hit your inbox, your great-grandfather might have been tossing aside a similar letter postmarked "Spain." The "Spanish prisoner" scam of 1910 used slightly better English, but the premise was equally preposterous. Consider yourself warned.*

FRAUD LETTERS FLOOD STATE
POSTAL INSPECTOR WARNS PEOPLE TO BEWARE OF HOARY-WHISKERED SPANISH APPEALS.

The attention of M.C. Fosnes, post-office inspector, has been called to an influx of fraud letters from Spain to persons in the Twin Cities and he believes that whoever is operating the hoax is receiving some returns from this territory and warns the public not to "bite" at the alluring bait. The letters have been many and the Spanish person is apparently untiring in his efforts in Minnesota. Many of the letters have been sent to the inspector.

The following is a sample of the letters received by Victor Segerstom, of the Segerstrom Piano company, and Harry Olstein, 205½ Washington avenue north:

Madrid 20-1-10.

Dear Sir—Although I know you only from good references of your honesty, my sad situation compels me to reveal you an important affair in

The downtown Minneapolis Post Office in about 1900. Behind it was the Metropolitan Building, then known as the Northwestern Guaranty Loan Building. *Courtesy Hennepin County Library Special Collections.*

which you can procure a modest fortune saving at the same time that of my darling daughter.

> *Before being imprisoned here, I was established as a banker in Russia as you will see by the enclosed article about me of many English newspapers which have published my arrest in London.*

> *I beseech you to help me to obtain a sum of 480,000 dollars I have in America and to come here to raise the seizure of my baggage paying to the registrar of the court, the expenses of my trial and recover my portmanteau*

containing a secret pocket where I have hidden the document indispensable to recover said sum.

As a reward I will give up to you the third part, viz., 160,000 dollars. I cannot receive your answer in the prison, but you must send a cablegram to a person of my confidence who will deliver it to me.

Awaiting your cable to instruct you in all my secret, I am sir,

A. DEMIDOFF.

Mr. Fosnes, in warning the public, says: "Instead of the writer being a wealthy party in temporary distress, he is a miserable Spanish scoundrel who very likely has been in jail many times. There may be a number of scoundrels working the same line of graft. Every dollar sent to Spain or sent for cablegrams is a tribute to rascality. Better throw the money into the Mississippi river."

Clairvoyant in Court on Vagrancy Charge

SEPTEMBER 23, 1911, *MINNEAPOLIS TRIBUNE*

A little over a century ago, a Minneapolis fortune teller—er, clairvoyant—landed in court, facing charges of vagrancy for charging an undercover cop one dollar to tell his fortune. The Tribune's account captures the color and detail of Mrs. Mary Jacobs-Solomon's first day on trial.

MYSTERY OF SPIRITS TOO MUCH FOR COURT
PSYCHIC TESTIMONY BAFFLES JUDGE C.L. SMITH AT MRS. JACOBS' TRIAL.
WOMAN ACCUSED OF VAGRANCY UNDER FORTUNE-TELLING CAUSE OF LAW.
EXPERT WITNESS FOR DEFENSE TELLS OF WOMAN'S SUPREMACY.

After several months of postponement and continuation, the case of Mrs. Mary Jacobs-Solomon, clairvoyant, charged with vagrancy under the fortune telling clause of the state law, came to trial yesterday.

The case was called at 2:30 p.m. At 4:30 p.m. Judge C.L. Smith wiped the perspiration from his brow and announced a continuation until next Friday. Stenographer Durant, who was taking the testimony, fell back in his chair, pale and trembling, but was revived with a glass of water, while Assistant City Attorney Compton thumbed the pleats of his Norfolk jacket, and seemed thirsting for more. This is the way the testimony sounded:

Mr. Compton: "You testify that while in the clairvoyant state you are conscious and that while in the trance condition you are not. Will you describe these conditions and tell why this is so."

Mrs. Jacobs: (The way she is reported by a stenographer not conversant with the arguments of spiritualism.) "The clairvoyant habit of mentality

is due to certain physical phenomena which have been demonstrated by science and which cause the subject while in a state passive and receptive to the rhythmic vibrations to become attuned to the spirit manifestations of the inhabitants of that sphere of life known to us as the realm of the spirit body. In a state of clairvoyance the subject is governed by the psychic forces which emanate from the physical, but in the deeper state of trance the normal mind is crowded out of the physical into the spirit body and the mind of the spirit control takes possession of the body of the medium, giving through that body expression to its own spiritual intelligence of the prophetic, or soul-sensing manifestation."

MOTHERLY LOOKING WOMAN.

To look at Mrs. Jacobs and to listen to her is a most astounding experience. All that is perceptible to the ordinary individual is a pleasant countenance and a motherly expression. It is not until she begins to speak that the remarkable part of the woman is recognized. She explained it all by this part of her testimony:

"I am constantly in touch with the spirit side. As I sit here testifying there are about four or five controls constantly about me ready to receive me into the state of trance."

With these words Mrs. Jacobs' eyelids began to tremble, she sank into the witness chair. She quivered and shook off the influence with a struggle and asked for a glass of water. This was the only relapse to the custody of the controls that she suffered while on the witness stand.

Mrs. Elizabeth Harlow-Getz of Springfield, Mass., one of the trustees of the national organization of Spiritualists, was put on the stand to testify to the tenets of the church to which Mrs. Jacobs-Solomon is said to belong. Mrs. Getz was fortified with whole passages of the spiritualist books and kept the stenographer busy.

After stating with rapid-fire precision the list of her beliefs Judge Smith interrupted:

"Madam, I believe every one of those things myself but I am not a spiritualist."

"Your honor must then be a spiritualist without knowing it," rejoined Mrs. Getz.

JUDGE TALKS OF SPIRIT POWER.

"Do you believe that when the subconscious mind, or spirit body as you call it, becomes more powerful the normal or conscious mind becomes weaker?" asked Judge Smith among other questions suggesting many hours of special reading for this particular case.

In 1911, most clairvoyants could afford only a few lines in the *Tribune*'s classified sections. Plastic surgeons, on the other hand.... *From* Tribune *microfilm.*

"I do," said Mrs. Getz. "The trained thinker or the highly educated person has difficulty in developing the spirit body. Illiterate persons furnish our most phenomenal mediums. Mrs. Jacobs is a phenomenal medium and demonstrator."

"Are women more perfect mediums than men?" asked the judge.

"Woman is the great pulse of the world and its rhythmic manifestations," replied Mrs. Getz, or words to that effect. "Men are attuned to the lower vibrations and move on a more materialistic plane." The judge changed the subject.

This testimony was offered to prove that Mrs. Jacobs (as she has been known in Minneapolis), was not guilty of the violations of state law when she accepted $1 for a "reading" she gave Detective Mealey, with Detective Gleason listening from a point of vantage just outside the window of the seance room.

"It was the same talk fortune tellers always give," said Gleason, when he told of the seance and declared he did believe Mrs. Jacobs when she says as she did on the stand:

"I know that I can communicate with the spirit side of life and I am firmly convinced that what I told Mr. Mealey while in a trance was a bona fide message from the spirit controls which guide me."

FOLLOW-UP: Judge Smith issued his verdict two months later. "A decision in municipal court yesterday," the Tribune *reported on November 16, "holds that the alleged transmitting of a 'fortune' told by spirits through an earthly medium makes the medium not a fortune teller, but a spiritualist, and therefore not a vagrant as adjudged by the recent state laws."*

A Dinkey Man's Sad Story

OCTOBER 31, 1912, *MINNEAPOLIS TRIBUNE*

Alas, the Minneapolis Tribune *did not provide readers with a translation of the century-old slang in this piece. Perhaps you'd like to take a shot.*

HE LOST HIS "BUDDY BOY" BUT THE POLICE FOUND HIM
SOMETHING NEW IN THE LINE OF SLANG IS UNCORKED AT HEADQUARTERS.
DINKEY MAN TELLS SAD STORY AND INTERPRETER IS NECESSARY.

He swaggered into police headquarters last night and edged up to the desk sergeant.

"I have lost me buddy," he said. "Me buddy has been kidnaped. He's been doped, I say. They just shot the hypo into him. Maybe he's been croaked by now," and he shed a silent tear.

"Who's Buddy?" was the gruff inquiry.

"Buddy's me pal, cul; him and me're both dinkey men. We worked to'gether for weeks. Say, tell me, can you find him for me?"

"What's 'dinkey men'?" asked the desk sergeant, now thoroughly interested.

BEEN RUNNING DINKEYS.

"Aw, we've been running dinkey cars out to Hopkins," was the impatient answer. "I know dey got him. Dey sifted him, that's what dey done," and he shook his head ominously.

"Sifted him?" There was a rising inflection in the sergeant's voice.

No dinkey men here: Minneapolis police and jail guards showed off their new riot shotguns in about 1910. *Courtesy Minnesota Historical Society.*

"Yep, sifted him, strained him, cleaned him, don't you know; put him through the cleaner and ribbed him for his cush. He had a rock on him, too, and dey maybe copped it. It was a swell piece of glass, I'm telling you."

"Where'd all this happen?" snapped the desk sergeant.

"Aw, I dunno. I ain't wise to the stems here yet. We meets a elegant piece of lace and she kind of cottons to me buddy and he falls for it, see, and dey goes away together. One of the hobbles lamps me, too, but I sidesteps and claps me hand over me roll, knowing it meant only highway robbery; but when I had made me getaway and has a look round, me buddy has vamoosed with the bundle of langsherie." He dwelt lovingly on the last word, giving the "a" the full, broad sound.

HIS BUDDY'S PICTURE.

"Now, I ain't no piker," he continued. "Here's me buddy's picture. Find him for me. I'm willin' to spend a hunderd bones on de job," and he flashed a respectable roll under the sergeant's fascinated gaze, who silently motioned him into the office of Louis Hansen, captain of detectives.

Captain Hansen hurriedly requisitioned a newsboy to act as interpreter and then sent out two of his men to find "Buddy." The recreant one was soon discovered and taken to headquarters.

The pair walked out of city hall arm in arm.

A Surgical "Cure" for Criminal Tendencies

JUNE 1901–SEPTEMBER 1925, MINNEAPOLIS TRIBUNE

*O*n June 28, 1901, Johnny Howard was one of thousands of boys and girls who gathered under the big top for Pawnee Bill's Wild West show at Twenty-fifth Street and Blaisdell Avenue in Minneapolis. At half past 3:00 p.m., a storm blew in and sent the huge tent canvas billowing skyward, taking stakes, ropes and poles with it. Then the whole works crashed to the ground, smothering screaming spectators and performers in a panicked mess. "Happily," the Tribune reported, "all were more frightened than injured."

Except one. Ten-year-old Johnny Howard had been struck in the head by a tent pole. Rain was still falling in a fierce torrent as he and others were pulled from the wreckage. He was first taken home and then to a hospital after his condition worsened. "Surgeons found that his skull had been fractured and that the bone was pressing against the brain," the Tribune reported. They decided to operate. By midnight, their work was done. By morning, his condition was much improved.

Most newspaper stories of this sort—boy on the mend after a serious accident—end here. But by all accounts, the brain injury transformed John S. Howard. After the wound healed, he complained of buzzing in his head and developed a taste for mischief. He refused to go to school and was sent to the reform school at Red Wing on a charge of incorrigibility. He spent fourteen months there. Soon after his release, he was arrested on more serious charges—one story says burglary, another says horse stealing—and was sent to the St. Cloud Reformatory in 1908. He was paroled in 1911, moved in with his mother and stepfather in Minneapolis and found work in the flour mills.

On July 18, 1912, he was jailed on burglary charges. His name appeared the next day in the Tribune for the first time since the circus accident. He promptly admitted his misdeed and hired Fred H. Ayers, an attorney, who soon suspected that the brain injury

Above: The *Minneapolis Tribune*'s front page of June 29, 1901, was dominated by a political cartoon on a tariff dispute in Congress. The top news headline detailed a line of powerful storms blowing across the state that had killed one and injured many others.

Opposite: Several ads for Pawnee Bill's Wild West appeared in the *Tribune* in the weeks leading up to the show. This one promised a "Strange and Startling Street Parade." *From* Tribune *microfilm*.

was a factor. Ayers and Dr. Albert H. Parks met with the county attorney and discussed the possibility of surgery "to relieve a pressure on his brain and thus cure him of his criminal traits." It was a popular theory of the time: to cure the moral defect, you must cure the physical defect. One Minneapolis surgeon, Dr. Harris Dana Newkirk, performed more than 150 operations "to correct delinquent boys and girls" in 1912 alone.

Upon the recommendation of the county attorney, a judge ordered Howard released into the custody of Ayers and Parks. On July 31, he was taken directly from the county jail to Asbury Hospital a few blocks away. Two days later, he was under the knife. To their surprise, Drs. Park and A.E. Wilcox found that it was not bone pressing on his brain but rather a cyst "about the size of a medium sized marble." They removed the cyst without difficulty, inserted a small silver plate to cover the opening and stitched it closed with catgut. The two surgeons declared the operation a success. The following comes from the Minneapolis Tribune *of August 6, 1912:*

BOY SEES MORAL LIGHT FOLLOWING OPERATION
JOHN S. HOWARD, CONFESSED BURGLAR, IS OPTIMISTIC SINCE SURGEONS' WORK.
FEELS GOOD AND REMARKS OF ABSENCE OF BUZZING IN HIS HEAD.
CRIMINOLOGISTS WATCH EFFECT OF REMOVAL OF PROBABLE CAUSE OF WRONGS.

John Howard, boy burglar, on whose skull an operation was performed Saturday, is rapidly mending. Yesterday he was in an optimistic frame of mind.

"I already feel like a new man," he said. "My head is clear today, clearer than it has been for many years. Words cannot describe the relief felt. I owe a world of gratitude to Mr. Ayers, Dr. Parks and Dr. Wilcox. I have not had a headache since the operation and that buzzing pain over my right temple has completely left me."

Although cases similar to Howard's are said to be infrequent in the annals of criminology, those who have made a study of the subject declare that every criminal should first be given a thorough examination to discover, if possible, whether the fault is traceable to physical defects which might be cured.

Fred H. Ayers, attorney for Howard, who first asked for an operation to relieve pressure on the boy's brain, declares that scientific

John S. Howard's pardon was front-page news on February 9, 1913. *From* Tribune *microfilm.*

means should have been adopted to cure him, if possible, when he first developed criminal traits.

"I firmly believe that Howard would never have continued in his career of crime if the officials of the Red Wing training school and the St. Cloud reformatory had recommended an operation when he was first sent there."

CONDITION NOT NATURAL.

"The boy naturally is not a criminal and, in my opinion, is no more to blame for his wrongdoing than a 2-year-old child for crying when hungry."

Rev. Thompson W. Stout, pastor of Calvary M.E. church, declared that the operation was the most sensible thing that the authorities could have recommended in the boy's case. "Where there is a physical handicap to a criminal it should be cured by scientific means whenever possible," said Dr. Stout...

Warden Wolfer of the Stillwater penitentiary said that cases similar to the Howard case were rare. "We have a thorough system of physical examination of prisoners, however, to discover such a condition, if it exists, and to remedy it if possible," he said, "but our experience has been that there are very few in which there have not been many other stronger influences to induce the commission of crime. There is no doubt, however, that there are cases similar to the Howard case where the criminal tendencies could be traced directly to an abnormal condition of the brain resulting from external causes"...

The "boy burglar," now twenty-one years old, continued to show signs of recovery from his criminal tendencies. But he and the courts faced a sticky question. From the Tribune *of August 13, 1912:*

CONVALESCENT BURGLAR IS READY FOR HOME OR JAIL
JOHN HOWARD EXPECTED TO BE WELL ENOUGH TO QUIT HOSPITAL ON THURSDAY. MAN WHOSE BRAIN PRESSURE WAS RELIEVED BELIEVES HE IS MORALLY WHOLE.

John Howard, boy burglar, will go from Asbury hospital to the county jail next Thursday unless action is taken by the authorities permitting him to return to his home. His trial is set for October and it will mean a wait in the prison of nearly two months. He says he believes the operation to relieve pressure on the brain has cured him of his criminal tendencies. His mother is also of the same opinion and the attending surgeons, Dr. Parks and Dr. Wilcox, feel certain that he will be a different man hereafter.

But this makes no difference so far as the law is concerned. According to the boy's attorney, Fred H. Ayers, a secret indictment was returned by the last

grand jury. The indictment has never been made public because it was feared that Howard might try to escape. Howard says no. He will be glad to face the music and trying to evade the law would be the last thing he would do, he says.

"I don't want to go back in jail if I can help it," he said when seen last night at the hospital, "but will do so willingly if Mr. Ayers and the authorities say I must. I am a different person now. Before the operation I didn't care what happened to me. I had no fear of dungeons and the county jail was the least of my troubles. Now I can see the world in a different light."

The boy's mother is praying that her son may be returned home next Thursday instead of to jail. "I simply cannot think of him going back to prison again," she said as she stood by her son's side. "He is a different boy now."

It's unclear when Howard was released from the hospital, or whether he spent any time in jail upon his release. But within two weeks of the operation, he had won his court case. At a hearing on September 11, Dr. Parks told a judge that in his opinion the boy had been completely cured. Upon the recommendation of the county attorney, the judge released the boy into the custody of his attorney.

In the months that followed, Howard began building a law-abiding life, finding work, paying the rent and marrying a young neighbor, Ethel Wilkes, who had stood by him after his July arrest. Unfortunately, the terms of his release prohibited him from marrying without permission of his parole agent. Howard sought permission but was refused. The couple, who became engaged before his arrest, couldn't wait. On January 23, 1913, they got a license from the clerk of the Hennepin County Court and were married. Five days later, Howard was back at the St. Cloud Reformatory to serve the remaining six months of his original sentence.

But love—and medical science—won in the end. The Saturday Evening Tribune *trumpeted the news on its front page of February 9, 1913:*

PARDON GRANTED TO JOHN HOWARD, FOR A FRESH START
BOY WHO BROKE PAROLE BY MARRYING IS TO HAVE EVEN CHANCE.
SPECIAL MEETING OF BOARD OF PARDONS BESTOWS CLEMENCY.
ACTION TAKEN ON PRESENTATION OF FACTS GATHERED BY THE TRIBUNE.
YOUTH'S WHOLE ATTITUDE TOWARD THE WORLD CHANGED SINCE OPERATION.
JUDGE, LAWYERS AND DOCTORS FAMILIAR WITH CASE ASKED HIS FREEDOM.

John Howard was pardoned Saturday. He is the boy who broke his parole from the St. Cloud reformatory two weeks ago by marrying, and was returned to St. Cloud to serve till October. People have been interested in him ever since Dr. A.E. Wilcox and Dr. A.H. Parks removed a tumor from

his brain last September and Judge Dickinson, on the advice of County Attorney Robertson, gave him a new chance to make good.

The Tribune, at the request of Howard's mother, gathered facts this week that showed that he was making good; that the operation had increased his intelligence, whether or not it had any effect on his criminal tendencies; and that, aside from his marrying against the wishes of the state, but on the advice of his friends and physicians, he had been living as the state wished.

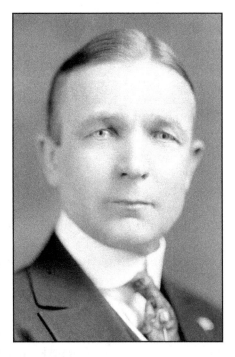

Minnesota governor Adolph Eberhart called a special meeting of the board of pardons to review Howard's case. *Courtesy Library of Congress.*

SPECIAL MEETING OF BOARD CALLED. These facts were placed before Governor Eberhart, Chief Justice Brown and Attorney General Smith Friday. These friends of Howard who had doubted the state's having a heart should have seen the reception of his story by these three high officials of the state. The board of pardons shouldn't have met until April, but the governor, as soon as he heard the narrative, himself offered to call a special meeting if the other two members could attend.

Chief Justice Brown left the supreme court bench to listen to the story. When it had been told he said: "I will attend a meeting of the board of pardons whenever the governor calls it." Attorney General Smith broke a luncheon engagement to attend the meeting. "That story should be told to the board of pardons at once," said he, "and it's much more important than a luncheon."

AND EVERYBODY HELPED.
Judge Dickinson, before whom the boy had been arraigned when he committed the crime that led to the performing of the operation, and County Attorney Robertson, who had nolled [dismissed] the indictment for that crime, joined heartily in the request for a pardon, and the doctors who had

watched him seconded their efforts. Everybody who knew Howard helped to get his pardon, and finally Fred Willner, night foreman of Consolidated mills, made his immediate future bright by providing a temporary job in case he was pardoned. His wife already has a job.

His pardon is based on the fact that the operation has not yet had opportunity to show its full effect and he is to report to the physicians from time to time till fully cured.

THE BOY'S HISTORY.

Howard is the son of a former North Dakota minister, after whom he was named. When John was a youngster his father disappeared and Mrs. Howard had to support the four children for several years. Finally she married Alex Morrison.

When John was 11 years old, he went to a circus and a storm blew down the tents. A heavy pole struck him on the head. After the wound healed the boy seemed to have developed a desire for mischief. He wanted to run away from home, to meddle in things that did not concern him, and he got into trouble of diverse kinds. His mother early blamed the accident and wished that an operation might be performed, but she could not afford it.

At last John was sent to the reform school at Red Wing. The charge was incorrigibility. He had refused to attend school. The incarceration did not help him. He complained at times of pains in his head, and it was immediately following these periods that he invariably got into trouble.

Then one day the state reformatory opened its doors and when they closed Howard was behind them. He had been convicted on the charge of grand larceny. That was in September 1908.

A little over a year ago he was paroled. Last July he was arrested for burglary.

AN OPERATION AT LAST.

Fred Ayers, his attorney, knew of the accident. He also knew of Howard's parentage and wondered at his criminal tendencies. He asked the court for permission to take Howard to a hospital, where an operation could be performed. Dr. Wilcox and Dr. Parks operated. They found a tumor on the brain, just above the right temple, at the spot where the tent pole had struck. The growth was removed and a silver plate inserted.

Many people who knew Howard have testified to the change they noticed in him after the operation. He was obedient, where he had been willful, quiet where he had been stormy, steady where he had been erratic, and diligent with a purpose. But there was one complete change that was queerest of all.

Almost immediately the boy's affections were developed to a marked degree. He delighted in playing with his sister's small children, he gave his mother aid, and he showed a willingness to be of help that he had not displayed after he was hurt.

Just a little over a year ago Howard's mother introduced Ethel Wilks ["Wilkes" appears to be the correct spelling, judging from birth certificates and Minneapolis City Directory listings] to her son. The girl was living next door to the Morrison home. They fell in love. When John was arrested the girl stood by him. After the operation his love for the girl was greatly intensified. He asked permission of the state parole agent, Jacob Z. Barncard, to marry. Mr. Barncard refused, although at that time Howard had a home ready for his wife.

FRIENDS TRY TO AID HIM.

He was working at the Minneapolis Steel and Machinery company's plant, ten hours every day. Every evening he spent with Miss Wilks. C.E. Bramhall, the foreman under whom he was working, took a great interest in him. Mr. Bramhall wrote Mr. Barncard, advising that he thought the boy would be greatly benefited if the state allowed him to marry. As a result of the letter Mr. Barncard wrote to Howard. He told the boy to "quit fooling with that girl" and attend more strictly to business. Evidently the parole agent had misinterpreted Mr. Bramhall's letter.

Then Howard and his stepfather had trouble over a bill for board. The boy was paying $5 a week. At Christmas he sent a sister $16 and gave his mother $5. He had to leave the board to be paid and the stepfather ordered him out of the house. He had no money. He went to a cheap rooming house downtown.

Mr. Barncard heard he was in this house and ordered him to leave. Howard had some pay coming from his employers, money held back when he went to work. He wanted to pay the bill held over him by the stepfather so he resigned his position to get back the money. When the bill was paid, he was penniless, homeless and without work.

HE WORKED AT ODD JOBS.

He worked at odd jobs and managed to make enough to obtain cheap beds and poor food. He would have had an easier time if he had not had to take his parole papers with him wherever he went. When he got a job he would have to pull out these papers, which testified to his having been in the reformatory, and get the new employer to sign them. More often than not the new employer would show him the door and Howard would have to look for another job.

His sister came home from the West about the time Howard's jobs were getting fewer and farther between. She, like all his other friends, advised him to marry. "If you're married the state will be lenient," she urged.

It was the advice that Howard wanted. But caution that the sister had not thought of occurred to Howard. He went to see Dr. Parks to get his advice. Dr. Parks was ill. The boy waited a week to see his adviser, and finally, in desperation, he married.

Then the state swooped down on him, had him arrested and sent back to St. Cloud to the rock quarries and tacked on an extra month of imprisonment because of the unfiled report. This was a week ago.

FRIENDS INTEREST THEMSELVES.

The doctors, lawyers and others acquainted with the case took exception to the parole agent's action in sending Howard back to the reformatory. They declared the move was a demonstration of the workings of a law machine which could not throw itself out of gear in order to oil its bearings with justice. Complaint was made to The Tribune by both relatives and friends and investigation resulted. Governor Eberhart's first statement after hearing the evidence was:

"I, for one, as chairman of the board of pardons, am in favor of immediate action looking toward the release of this man."

Then the governor said he would call a special meeting of the board of pardons. The first meeting was held at noon Friday and the second Saturday morning. Five recommendations for Howard's pardon were presented on Saturday. They came from County Attorney James Robertson, Judge Horace D. Dickinson, who had heard evidence in the case; Fred Ayers, his attorney; Dr. A.E. Wilcox and Dr. A.H. Parks.

Men who had formerly worked with Howard were unanimous in their praise. They said no one could have worked harder or more conscientiously than did this boy after the operation. He sought permission of his foreman at the steel works to enter a school conducted for men who desired to learn engine repairing. The company conducts the school and graduates are sent on the road. Howard studied hard and was progressing well when he had the trouble with his stepfather which resulted in his resignation.

COMMENDED AT REFORMATORY.

At the reformatory, officials commended Howard's deportment. Fred Whitney, principal keeper and acting superintendent, said the boy never caused trouble. In the three years spent in the institution before being

paroled, Howard offended only five times. In those cases he was charged three times with talking, once with talking and idling, and once with having lighted a string with a match. All these were before the surgical operation. He worked in the stone cutting shops.

Mr. Barncard said that the incarceration came solely because of Howard's marriage. He said he was forced to send the boy back to prison. Dr. Parks took exception to this action with the statement that if every man who married when he should not do so were arrested the Minnesota appropriation for penitentiaries, reformatories, etc., would have to be greatly increased.

"I couldn't see that the boy's wanting to marry was a crime," said Dr. Parks. "It would have helped instead of harmed him. But the state kicked him instead of assisting him. If the state is afraid a man is going to be a criminal it should not lock him up. First, it should give him an opportunity to be crooked. Howard was trying to do right. He was made desperate because he had no friends, no money and no work. The girl stood by him through it all and he turned to her for everything. Love is centuries old and the boy was human. He waited over two months for permission to marry and then he couldn't wait any longer.

THE CAUSE OF HIS DEFICIENCY.

"My contention is that crime is largely a matter of mentality. This boy had gone below par as far as mental ability was concerned. I am positive it was the tumor that caused the deficiency. I do not claim that the operation cured him of his criminality. I claim it helped him mentally. Help a man mentally and you help him physically. Help him mentally and physically and you are bound to help him morally. We were working along this theory with Howard and he was responding nobly. What more could be asked?"...

"All I want is a chance," was the ordinary expression by Howard when he was interviewed in the reformatory..."I know that I am a different man and have been ever since the operation. When I think of the things I have done I can hardly believe that I could have been so crooked. That's what makes me think the operation was a success. I never have those headaches any more and my head is clear all the time. I can remember things a whole lot better than I could before. If they will just let me go back to my wife I know she'll help me to follow the right path. I love her too much to disgrace her."

On February 9, John S. Howard walked out of the St. Cloud Reformatory a free man. Did he follow the right path? For more than a decade, it appears that he stayed on the right side of the law.

Minneapolis's Gateway Park in 1922. Howard admitted to stealing $47.50 from a pocketbook in an office in the Temple Court building, the eight-story structure at right. *Courtesy Hennepin County Library Special Collections.*

Form 109 6-24—5M	**HISTORY SHEET**	Case No. **8231**	
	Minnesota State Prison		
	Name of Institution	SBC No.	
True Name	**John Howard**	Date Admitted	**Sept 16 1925**
Alias	**None**	Date of Sentence	**Sept 15 1925 Co. Hennepin**
Residence	**Mpls Minn**	Court Record	
Date of Birth	**1894**	Trial Judge	**Hon Mathias Watts**
Time in U. S.	Landing date	County Attorney	**Floyd B Olson**
Time in State **25** Yrs.	Mo.	Crime	**Gr Larceny 2nd Deg**
Sex **male** Color	**white**	Max. term **5**	Min. term **0**
Color Hair **D Ches** Eyes **D Brow** Build **Tall**	Sentence **Ind**	Fine $	
Height **5** ft. **11½** in. Weight **157½** lbs.	Pleaded guilty **yes**	Not guilty	
Beard Complexion **Fair**	Inmate consider fair trial? **yes**		
Married or single **Married**	Particulars of Crime, time, place		
Education **8th Grade** Religion **Catholic**	**Stole a pocket book containing $47.50**		
Correspondent	**from Temple Court Bldg Mpls Minn**		
Address			

A portion of the Prison History form filled out upon Howard's arrival at Stillwater Prison on September 16, 1925. Note the name of the county attorney: future governor Floyd B. Olson.

Friends said that they saw a great change in him. He was now "obedient, quiet, steady, diligent and affectionate," according to one newspaper account. Between 1913 and 1918, John and Ethel had four children: John L., Margaret, Grace and Audrey. He worked as a streetcar motorman in Minneapolis for a few years. In June 1917, he registered for the draft, listing his occupation as laborer for the Chicago Milwaukee & St. Paul Railway and his place of birth as Moosomin, Saskatchewan. His description is given as tall and slender, with brown eyes and brown hair. At some point, the couple "had troubles," and he moved west without the family, finding work in the oil fields of Wyoming, Colorado and Montana. "I made good money out there," he recalled years later, "$6 and sometimes $8 a day." After four years, he returned to Minneapolis and made up with Ethel. He found work in the flour mills. The couple had a fifth child.

Then, in about 1923, Ethel left him. He was working at the Milwaukee Road Depot as a baggage handler when his head began bothering him again. He suffered severe headaches and blackouts. "I couldn't hold a job," he said. "Every time I got one, I'd have one of my spells and I'd get fired." He called on Dr. Cox for help. The surgeon decided that the silver plate was at fault and removed it.

The spells got worse. He bounced around from the Dakotas to Minneapolis, Chicago, Detroit, Cleveland and back to the Twin Cities. Unable to hold a job, he turned once more to crime. In August 1925, he was arrested on charges of stealing cash from purses and pocketbooks in buildings throughout downtown Minneapolis. Twenty-five stenographers identified him as the thief. He pleaded guilty to one count of grand larceny in the second degree for stealing $47.50 from a pocketbook on a desk at the Temple Court building in Minneapolis. He was sentenced to five years in Stillwater Prison.

The file of prisoner no. 8231 is full of sad detail. In intake interviews, he attributed his downfall to "Trouble in my head." Cocaine use and a history of gonorrhea are noted in another document. His wife sent most of the children to their paternal grandmother in Kentbridge, Ontario. She got a cleaning job at the Pullman Company, earning less than one dollar per day. Her rent alone was twenty dollars per month. He regularly sent her a portion of his prison earnings, two to ten dollars per month. She applied for state aid and was denied. He applied each year for parole and was denied. She was later run over by a car and was hospitalized. She also contracted scarlet fever and was again hospitalized. He was put in solitary confinement for stealing a spoon that he planned to make into a belt buckle. He wrote dozens of letters to friends and family each year, including several to his "Dear Niece Alice" in elegant longhand.

"Well, sweetheart," he wrote to her on January 24, 1926, "here it is letter day again. I sure am glad when I can talk to you even though only on paper. That is something to be thankful for, gee how I would love to see you and talk to you dear…I told you I had something coming did I not. Well I sure have and you are sure to share it if you care to wait for you know dear everything comes to him that waits, and I think you are sure a good waiter."

That letter never got to Alice. It's still in Stillwater Prison File 8231 at the Minnesota History Center's library in St. Paul. An accompanying note—signed "Clark," presumably a prison officer—says, "I think this is his sweetheart instead of his niece and according to the correspondence he has a wife in Minneapolis."

Howard was released on May 3, 1929. Within a year, the scattered family was back together in a house at 1404 East Nineteenth Street, Minneapolis. The 1930 census lists John S. Howard as head of household. His occupation is given as "tinner" in the sheet metal industry, unemployed. Ethel Howard's occupation is given as "Pullman seamstress." The children are listed as John L., sixteen; Margaret, fourteen; Grace, twelve; Audrey, eleven; and Arnold, seven.

I can find no trace of the family in the 1940 census. Newspaper accounts and military records show that the youngest son, Arnold Sherman Howard, enlisted in the U.S. Army Air Corps in San Antonio, Texas, in February 1943. He survived World War II but not the Korean War. His B-29 crashed in the Sea of Japan on September 15, 1951. His remains were never found.

The last trace of his father is the final document in Stillwater Prison File 8231: a 1936 memo from the Federal Bureau of Investigation (FBI) with a fresh set of fingerprints. John Sherman Howard was under arrest in Oakland, California, charged with burglary.

Who Cut Mary's Hair?

JANUARY 23, 1915, MINNEAPOLIS TRIBUNE

*M*ean *boys have been terrorizing schoolgirls since blackboards were invented. But rarely does a bully land in court—or in the pages of the local paper. In 1915, an angry father and his eleven-year-old daughter stood in a Hennepin County courtroom and accused "the meanest boy" in school of lopping off the girl's auburn curls. A* Tribune *reporter was there to capture the drama.*

Within weeks, the alleged bully, Eddie Schmidt (or Smith), was cleared of the charge of assaulting Mary (or Katherine) Weinand on her way home from a one-room schoolhouse a few miles west of Corcoran. The Tribune *played that development as a whodunit, asking, "Who cut Mary Weinand's hair?"*

There are no further mentions of the case in the Tribune, *and despite my above-average Googling skills, I have not been able to solve the mystery. But I did find Allan Weinand, whose grandfather, Art Weinand, was in Mary's class; Art and Mary were first cousins once removed.*

Allan, a genealogy enthusiast from Mabel, Minnesota, confirmed that Mary attended the Corcoran school—officially, the Burschville School—with her twin brother, Michael. Allan himself attended the one-room schoolhouse until it closed in 1967.

"MEANEST BOY" FOUND; CUTS OFF GIRL'S HAIR
CORCORAN MAN DEMANDS ARREST OF YOUTH WHO DISFIGURED CHILD.
ONCE LUXURIANT CURLS REDUCED TO SHOCK OF JAGGED "BOBBED" HAIR.
CASE IS REFERRED BY THE COUNTY ATTORNEY TO JUVENILE COURT.

A girl, 11 years old, with big brown tear-filled eyes and ragged remnants of what had been a mass of auburn ringlets, went to the Court House

Girls! Lots of Beautiful Hair

25-Cent Bottle of "Dander-
ine" Makes Hair Thick,
Glossy and Wavy.

Removes all Dandruff, Stops
Itching Scalp and
Falling Hair.

Keeping long hair pretty has never been
a simple matter. Girls of 1915 were
advised to use Knowlton's Danderine
treatment to achieve "soft, lustrous,
fluffy, wavy" and dandruff-free hair. *From
Tribune* microfilm.

yesterday to tell of the "meanest boy at our school."

With the little girl came her father, Matt Weinand, Corcoran, Minn., the big angry man leading the frightened child. Arthur Conley, assistant county attorney, interrupted in his study of the career of a notorious forger, heard their story.

"There is a big boy that goes to school out there at Corcoran," began Weinand, "and he makes life miserable for all the smaller children. I didn't say anything before, but yesterday he began teasing my Katherine." And then to the little girl he said, "Katherine, show this man your curls."

Hesitatingly the little girl took off her cap. On each side cascades of auburn curls tumbled down over the child's ears, but in the back was a mass of ruins where the curls had been lopped off. Hurriedly the child pulled on her cap again.

"See what he did," raged Weinand. "Yesterday while my little girl was on her way home from school this Schmidt boy followed her and when they were off the school grounds he grabbed her and

School year 1911-12. First row, left to right: Louis Kalk, Bert Weinand, Mike Weinand, Stanley Strehler, Raymond Strehler, Art Wieinand, Sophie Schmidt, Esther Lange, Rosa Schmidt, Susan May, Teacher Miss Shanker. Second row, left to right: Mary Weinand, Minnie Lange, Viola Lange, Florence Priebe, Eddie Kalk, Henry Weinand, Ellen Lange, Lillie Priebe, Irene Krone, Sylvia Priebe, Jack Geurs, Walter Roehlke. Third row, left to right: Ida Kalk, Mable Weinand, Clarence Strehler, Gust Schalo, Charles Kalk, Gilbert Roehlke, Ruben Weier, Charles Priebe, Emil Schalo.

Burschville school's class of 1911–12, three years before Mary Weinand's run-in with a bully. If you squint, you can make out the curls on one of the two girls behind the desk at the front and center of the room. The girl on the left is Mary. Alas, no sign of that Schmidt boy, no matter how hard you squint. The photo is from *100 Year History of Burschville School*, a booklet published in 1994.

cut off her curls. I want to see him arrested. If the law won't punish him I will sue him and his father for damages."

Mr. Conley referred Mr. Weinand to the Juvenile Court authorities, as the accused boy is only 15 years old. Edward Davenport, Juvenile Court officer, told the father and child to return today with witnesses.

A month passed before the case appeared again in the pages of the Tribune. *Without explanation, the Weinand girl is now referred to as Mary instead of Katherine, and the alleged bully is now Eddie Smith instead of Schmidt. And the case remains unresolved.*

WHO CUT MARY'S CURLS, STILL A SCHOOL MYSTERY
LOSS OF LITTLE MISS WEINAND'S HAIR A VEXING QUESTION IN CORCORAN CLASSROOMS.

There is still mystery in the air in the Corcoran School. Small boys whisper about it behind their geographies. Little girls write furtive notes behind the teacher's back.

Who cut Mary Weinand's hair? For nearly a month the question has haunted the classrooms of the school and complicated the multiplication table. The matter has even been brought before the Hennepin County Juvenile Court. Still there is mystery.

Mary Weinand is one of the prettiest girls in the Corcoran School. Ringlets of hair rolled down her neck in profusion. But one noon when she returned home the pretty ringlets were gone. Some vandal, she said, had hacked off the curls with a pair of scissors.

Suspicion pointed to Eddie Smith, one of the larger boys in school. He was hauled before the Juvenile Court two weeks later, but against him there was no evidence to convict him. So Judge Waite dismissed him. Now the mystery grew, and gossips said that Mary had cut off her own curls to escape tedious attendance in school. But in a letter to Mr. Weinand Judge Waite denies that solution of the mystery was arrived at.

This photo of the Burschville schoolhouse was taken in the summer of 1965, two years before it closed. Standing in front were Allan Weinand (center); Agnes Weinand, his great-aunt; and Willard Weinand, his father. Allan entered the third grade at the school that fall; his great-aunt and father also attended the little school—as had his grandfather, brothers and other relatives over the years. *Photo provided by Allan Weinand.*

"It did not transpire at Eddie Smith's trial," he wrote, "that Mary cut off her own hair. I did not so decide nor intimate, nor did I come to any such conclusion. All that I decided was that evidence was insufficient to show that Eddie Smith did what he was charged with doing. This being decided, there was no necessity for me to determine anything further, so I did not."

Eddie and Mary have both been absolved of guilt. Mary's curls are growing out again. But still there is mystery hanging over the Corcoran School.

116

Tonka Bay's "Man of Mystery"

MAY 24, 1916, MINNEAPOLIS TRIBUNE

A tale of love and loss (and possibly stalking, embezzlement, alcoholism and domestic abuse) in a "fashionable" village on the south shore of Lake Minnetonka.

"MYSTERY MAN" SPENDS FORTUNE IN LOVE'S QUEST
TONKA BAY COTTAGER EXPLAINS STRANGE COURSE TO SHERIFF LANGUM.

GIRL DIDN'T WANT RICH MATE, HE SAYS
SO HE BECAME SPENDTHRIFT AND NOW HAS $3.18 IN HIS JAIL CELL.

After a week in the county jail Charles Palmer, Tonka Bay's "money spender" and "man of mystery," last night broke a silence of more than a year and explained to Otto Langum, sheriff, how he dropped from a man of wealth and leisure to a jail cell and cash capital of $3.18.

The girl he loved—and for whom he still cherishes a lingering loyalty— informed him, says Palmer, that she never could love one of the idle rich, a waster, a spender, but that she could cherish a keen affection for a poor man, a producer, a creator, a contributor to the world.

OUTDOES CARNEGIE.
Acting upon the suggestion from the girl he loved, Palmer informed the sheriff, he proceeded to get rid of his fortune. In seeking to accomplish this he met none of the difficulties which Andrew Carnegie tells about. In fact, so Palmer told the sheriff, if Carnegie is sincere in his determination to die

poor he can obtain the necessary formula by applying to Charles Palmer, address—Hennepin county jail.

Palmer, it may be remembered, has figured in two romantic episodes at Tonka Bay, to say nothing of being the continuous central figure of speculation on the part of summer and all the year round residents of the fashionable Minnetonka village.

In Gun Episode.
Last summer Palmer shot William Hardy, a jitney bus driver, in the arm when Hardy called at the Palmer cottage at Tonka Bay and opened fire on Mrs. Hardy, who was Palmer's housekeeper.

And on the night of May 17 last, Palmer played a leading role in the second adventure when he was arrested in the garden at the home of Dr. C.D. Fisher at Tonka Bay. On this occasion Palmer was armed with a revolver and had called, he claims, with the intention of saying farewell to Miss Jessica E. Davidson. He now is in the county jail awaiting grand jury action on a charge of carrying a concealed weapon.

On April 17, 1915, Palmer first put in an appearance at Tonka Bay. He rode up the boulevard drive on a motorcycle. So far as the villagers could discern he carried no baggage.

Always Paid Cash.
Palmer found a cottage which met his approval and rented it, paying $175 in cash for the season. That payment was the first of many cash payments which eventually added to the suspicions of the villagers. Palmer always paid in cash. Further, so the villagers say, he received no mail, which same was taken as another suspicious incident.

Needing a housekeeper Palmer advertised and Mrs. Hardy was given the position. Then he purchased a motor boat at a substantial figure—paying in cash. Before he had time to become accustomed to this first motor boat the whim moved to give it away and buy another and more expensive motor craft. Again the cash payment.

Shooting Is Overlooked.
Gossip grew real bold when in July last year Hardy drove out to Tonka Bay in his "jitney" and opened fire. The villagers never have taken exception to the conduct of Palmer on that occasion. When the shooting was going on Palmer obtained his own weapon and returned the fire, dropping Hardy with a bullet in the arm.

In fact, it was Hardy who was locked up on that occasion and it was Palmer who went to his rescue. No one ever entered [a] complaint against Hardy and he was released.

"That's the sort of sympathy I had for a poor devil in jail," Palmer told the sheriff last night. "No one seems to entertain a like sympathy for me."

OPENS SPENDING CAMPAIGN.
It was after that, so the talk of the neighbors goes, that Palmer opened up his real money spending and giving away campaign, and it is said to have continued until he left Tonka Bay late in the fall.

Possibly the oddest thing of all about Palmer in the estimation of the villagers is that he refused absolutely to tell anything about himself, where he came from, who his folks might be.

CHERCHEZ LA FEMME.
Not even when the sheriff questioned him following the Hardy shooting would he talk of himself. Nor would he the night of May 17 last when he was arrested in the Fisher yard. But last night he talked.

"See all those cells?" he demanded of the sheriff. The sheriff said he saw them.

"Well, they are full of men, most of them pretty good men. And most every one can lay his fate to a woman. I am no 'Adam' and I still cherish faith in women, but I guess I am through with them.

CAME FROM MAINE.
"I was born in Norcross, Me. My father was wealthy. I left home at 17 and am 36 now. When I left home I enlisted in the army and served 37 months. After that I was coached by a private tutor and became an expert accountant. I made big money.

"I was an accountant for many years. Then father died and sister and I had words over the division of the estate. At the same time I did the only crooked thing I ever have done. I was engaged by a big firm to audit the books. The regular bookkeeper was a friend of my father's. I found a discrepancy of $1,800. I gave the bookkeeper a chance to make good. He couldn't. I offered to lend him the money. He told me his story—his daughter had wished a college education— his wife was in society and he had fallen. There it is—women again.

LET BOOKKEEPER ESCAPE.
"I did not report the shortage. I was false to the men who employed me. I do not regret it. But I admit the fault. This incident, coupled with the quarrel with my sister, caused me to desire to bury myself. I converted all I had saved,

A crowd of well-dressed citizens lined up to board the steamer *Plymouth* at Tonka Bay in 1901. *Courtesy Hennepin County Library Special Collections.*

all the profits from my investments and all my father had left me into cash and found Minnetonka and Tonka Bay.

"It was there I met the girl I loved. She was everything to me. The easy life led me to drink heavily. It won me to dissolute ways. Leastwise it was leading me that way until I met her. She told me that wealth was not for me. She told me to get rid of my money, to be poor and to go to work.

WOULD EARN HER LOVE.
"To earn her love, I proceeded to follow her advice. It was not difficult."

Palmer was told that gossip at Tonka Bay reported that he had spent $15,000 there last summer.

"Never mind what it was," he responded. "But I didn't begin to spend until I left there last fall. I completed the job during the winter.

"I returned to Minneapolis May 17. I intended to say good bye and then go west to herd sheep, to work, as she had told me to do, to be a producer. And when I went to say good bye I was arrested.

"When arrested I had left of my fortune $3.18. So, being a beggar they threw me into jail."

House of Secret Chambers

DECEMBER 10, 1916, *MINNEAPOLIS TRIBUNE*

*U*pon *investigation, a mysterious explosion at a modest home in northeast Minneapolis appeared to have been a simple case of theft of natural gas. Or was it? What concoctions were the homeowner and his nephew mixing in the basement? Who was this oddly named reporter, Luman U. Spehr, whose byline appears only on one other story in the Tribune? And what poor copy editor had to write nine headlines for this piece?*

DEATH BARES HOUSE OF MYSTERY IN NORTHEAST MINNEAPOLIS
POLICE PUZZLED BY HIDDEN CLOSET IN BERAN HOME.
INVESTIGATION REVEALS TUNNELS, FORGE, SECRET CHAMBERS AT 1122 JOHNSON ST.

UNCLE AND NEPHEW ARE KILLED BY BLAST
THEY WERE AT WORK TAPPING GAS MAIN WHEN THEY MET DEATH.
HUSBAND REFUSES TO LET HIS WIFE KNOW OPERATIONS.
WOMAN UNABLE TO TELL POLICE WHAT HELPMATE CREATED IN CELLAR.

PATENT MEDICINE IS MADE IN BASEMENT
CACHE REVEALS BAG OF DISCS THAT RING LIKE GOLD PIECES, DECLARE POLICE.

BY LUMAN U. SPEHR.

Smoke never curls cheerily and hospitably from the cold chimney that juts out of the roof at 1122 Johnson street northeast. Now the place is vacant—it is a house of tragedy—two men died violently there two weeks ago. But even

before, for more than a year, that commonest sign of human habitation, smoke, was never seen. Its absence was noted even by the little-observing neighbors.

A very ordinary house on an ordinary street, painted years ago a dull, gloomy gray, with an unkempt lawn and a ragged, uncurbed boulevard, it looks like the home of a manual worker, poor and struggling for an existence. In summer a weed-like vine crept over the iron fence partially concealing the place from passersby, but the frost has stripped it of its leaves. A gaunt maple thrusts its bare branches out in a vain effort to brighten the effect.

Behind the house there is a neat mound of rock slabs weathered to tombstone whiteness. No opening breaks the continuity of the fence in the back. The only entrance to the premises is through the front gate and that is now held against morbidly curious trespassers by a chain and padlock.

PIGEONS OWN ROOF.

A hundred pigeons perpetually strut along shelves placed in rows on the roof, appearing and vanishing through holes cut for their use. It looks like the home of a hard-working laborer as it was supposed to be. Death lifted it out of the ordinary and revealed its many mysteries.

Two weeks ago today, along toward evening, a report came to the police that two men had been killed in a gas explosion under this little house. In the hope that they were still alive an ambulance, equipped with a pulmotor, was sent to the scene. Policeman G.H. Connery of the East Side police station accompanied it.

In one corner of the dark, cluttered, gas-filled basement, the patrolman found, half hidden beneath a shelf, a hole in the stone wall. It was the opening of a tunnel. Connery moistened his handkerchief, wrapped it about his face and crawled into the home, using his electric torch to light his way. Five feet in, the tunnel turned at right angles, ran for a few feet, and angled again around another corner.

FINDS FIRST VICTIM.

At the second angle Conner discovered the legs of a man. He crept to him. The tunnel narrowed. He flattened out on his stomach and wriggled forward. He reached the body, placed his ear to the breast and heard a faint heartbeat.

Quickly he drew himself over [the] body and wriggled on 10 feet to where a second tunnel jogged off from the first. He entered it and at its end, almost against an uncovered gas service pipe he found a second man, much older than the first. Again he applied his ear to the breast. This man was already dead.

December 10, 1916: anchored by a marvelous photo illustration, the story behind the "House of Mystery" dominated a section front of the *Minneapolis Tribune*.

There was no room to turn around. Conner slid backward over the young man's body and took hold of his legs. He dragged and pulled and tugged but without avail. The man's legs were curved round the turn in the tunnel and he could not budge him. His movements were hampered by the narrowness of the tunnel. He could get no purchase to brace himself for a strong pull.

CONNERY NEARLY OVERCOME.

Connery had been in this for nearly ten minutes and all the time, despite the dampened handkerchief over his nose, had been breathing gas. While tense with the excitement he did not notice it, but it had been gradually taking hold of him. As he lost hope of moving the living man he grew suddenly weak and

dizzy. He was barely able to creep back to the tunnel mouth. He staggered to his feet and into the arms of the waiting ambulance driver. He was hurried into the air and given a restorative while the driver phoned for the fire department.

There is a special equipment of life saving apparatus, an oxygen helmet with a supply tank, on No. 1 squad wagon at Station "A" ready for just such emergencies. Men were hurried out with this apparatus to effect a rescue. But the apparatus was useless in this case. The tunnel was too small for a man to enter while equipped with it.

Pipeman John Johnson of No. 1 squad wagon, abandoned it and entered the hole…like Connery he tugged in vain to remove the first man. The gas was getting stronger. It was not long until Johnson struggled out of the opening and collapsed insensible in the arms of his mates. He was taken to St. Barnabas hospital where he recovered consciousness three hours later.

Dig into Tunnel.

Certain now that attempts to remove the bodies, with the gas in the tunnel, were futile the firemen began digging through the lawn outside the house to reach the opening. For an hour or more they used pick and shovel on the frost hardened ground. At last they broke through and the gas gushed out.

Fifteen minutes later both bodies had been taken from their tomb and lay on the grass beside the house. Two City hospital doctors worked with pulmotors on both bodies but the last flicker of life had gone long before.

Detective J.J. McGuire was sent to investigate the deaths. He met the woman of the house outside and she told him her name was Beran and that it was her husband, Edward, and nephew, Wendell, who had been asphyxiated. Edward had worked as a machinist for the Minneapolis Steel and Machinery company. Wendell had been an electrician. She could not tell what the men had been doing in the basement. Her husband seldom let her go there and never told her what he did during the hours he spent there.

Gate Signal Discovered.

As he opened the front gate McGuire heard a click at this feet. Fastened by a pivot to the fence he found a catch so arranged that the opening of the gate would trip it and pull a wire leading along the fence to the side of the house where it was attached to a lever. Like the fence the trigger and wire were painted green and would never be seen if not sought for. The lever was painted gray to match the house. Inside under a shelf in the cellar way he found a bell on a piece of spring steel. The lever worked this bell. It was a most efficient guard against a surprise visit.

McGuire's curiosity was aroused and he entered the house alert for the unusual. Down steep, narrow stairs he made his way to the dark basement. In one corner he found a hole, three feet high and two feet wide in the stone wall. It was the mouth of the tunnel. A great stone fitting snugly into the opening had been set on iron pivots and swung easily open and shut. When it was closed only the closest scrutiny would have revealed it. A wide shelf over it hid it completely.

Tunneled to Gas Main.

The first section of the tunnel was brick lined. It angled toward the left a man's length inside and a little further on made another angle until it ran parallel to the front foundation wall. McGuire found its end at the gas service main outside the meter. The pipe had been tapped, some time before, the detective decided from the rust on the pipes.

Crawling back McGuire entered the second tunnel which led off from the first and met the service pipe in another place. This tunnel was freshly made and unlined. He found two holes bored in the service pipe and plugged with oily rages. It had been the dislodging of one of these rages which had caused the fatal leak. An oil lamp at the side accounted for the explosion that stunned the men and rendered their escape from the gas impossible.

Made Medicine in Cellar.

The pipes led to a stove upstairs and holes in the basement floor made McGuire believe it had been the intention of the men to connect a forge and boiler with them. He found that their gas bills had always been small. The same was true of their water bills. The water pipe had also been tapped outside the meter and the break hidden behind the fruit jars on a shelf so that suspicion never entered the minds of the meter readers.

The basement was small and so piled with boxes, boards, tools and miscellaneous articles, mostly rusty, that there was hardly a place for McGuire to set his feet as he moved about. There was a homemade, crude, but effective, forge with an equally crude bellows. A section of a huge steel shaft had evidently been used as an anvil. In one corner under a broken window was a bathtub.

A small melting pot with a molding board lay in one corner, behind boxes. A large, sheet metal boiler with water spouting soldered together in coils inside sat on a brick fireplace. The whole thing was homemade. It had been used for boiling herbs. The Berans ran a patent medicine business as a side line.

In the kitchen was a coal range converted into a gas burner by the inventive genius of the Berans. The fire box was filled with large cinders burned by the gas till they were blood red. Iron pipes had been coiled inside the range and led off to a water tank, the upstairs rooms and pigeon loft. These pipes furnished the principal heat for the house. All the plumbing was homemade; there were no flush tanks nor sewer traps.

YOUTH EXPERT PHOTOGRAPHER.

Many photographs, the work of an artist, were tacked about the downstairs walls. Wenzel Beran had taken them. He was a jack-of-all-trades and more than ordinarily competent at most of them. His room at the front of the house contained three cameras, photographic apparatus, a typewriter and a valuable old violin. A table held the usual young man's litter.

McGuire found the two rooms on the second floor. A trap door in the wall of the rear room opened into a pigeon loft filled with pigeons. A small photographic darkroom had been made out of a closet. In it was an enlarging camera that experts have since declared a marvel of workmanship and effectiveness. A stack of shelves was filled with dusty hats of all descriptions.

Good for what ailed you: a *Tribune* ad for Humphreys' "77," a remedy that almost certainly did not contain pigeon blood, an ingredient purportedly used in the Berans' patent medicine. *From Tribune* microfilm.

Another pigeon loft, filled like the other with birds, was entered through a trap door in the ceiling of the front room. A heavy stench from both lofts made the air in the house nauseating. In a rack covering one end of the wall were paper cartons, bottles and labels used by the Berans in their patent medicine business. Several cylindrical boxes held senna leaves, licorice root, aloes, and other herbs used by them in making the medicine.

Beside the door a part of the wall had been cut away and a door attached. The door had been papered and so neatly had the work been done that with the door closed the presence of this secret chamber would never have been suspected. McGuire began tapping the walls. On the other side of the door he struck a place that sounded hollow.

FINDS SECRET CHAMBER.

Hidden beneath a bunch of dill stems hung on the wall he found a string and by pulling this he opened a second secret chamber. On the floor inside he found a small bag containing metal discs, reddish yellow in color, and the size of a $5 gold piece. They rang like gold when dropped on the floor. Pressed into their face he found what seemed to him to be an Indian head, but the image, if there was any, was too faint to be clearly distinguished.

The discovery of these discs recalled the finding of the melting pot and mold in the basement. Later he learned from neighbors that a man, who hinted at being the agent of a foreign government and that Beran had committed some breach of the law before leaving his home land, Austria, had been inquiring about Beran some months previous.

The discs seemed to be made of two metals and McGuire decided that the man had been experimenting in an attempt to find a combination that would be a close imitation of one of the precious metals.

As McGuire descended the dark, narrow stairs, his investigation finished, he marveled at the ingenuity of the two men. Nearly everything he had seen was the product of their handiwork.

Several things he could not account for:

What had they done with the earth taken from the tunnel?

Was pigeon blood used in the patent medicine as neighbors averred?

Had a secret service agent been looking for Beran, and if so, why?

Why had men, with the mechanical cleverness these two displayed, resorted to theft to save a few dollars on gas bills?

Why did they guard themselves against surprise by installing an alarm bell?

What had the secret chambers been made to conceal?

What were the metal discs to have been?

McGuire pondered over these questions as he left, but he could only surmise the answers. The truth died with the two men in their self-made sepulchre.

FOLLOW-UP: Good questions all. I'll add two more: What about the wife? Surely she knew something about the activities under her roof. And who might have bought the patent medicines made by the men? Unfortunately, no follow-up to this intriguing story can be found in the Tribune *archives. The house at 1122 Johnson was razed, along with those of all the neighbors on the block, to make way for a section of Interstate 35W completed in 1975.*

Married by Hypnosis

JANUARY 13, 1921, *MINNEAPOLIS TRIBUNE*

For three cents at the newsstand, readers of the Minnesota Daily Star *got a steady diet of cops, courts and human interest stories. Much of it was ripped from the wires; others, like this page-one story, were written by staffers toiling in anonymity. Long before Rohypnol, there was hypnosis.*

GIRL'S MARRIAGE ANNULLED; SAYS SHE WAS HYPNOTIZED

Judge E.A. Montgomery today annulled the marriage of Marvel Lange Linnehan, 19 years old, and George E. Linnehan, 30 years old. They married April 5, 1920. The girl bride charged that she had been forced by hypnotic influence of her mother-in-law into the marriage against her will.

She testified that when taken before W.E. Bates, court commissioner, by Linnehan and his mother, she refused to answer the questions asked her during the marriage ceremony.

According to the story Mrs. Linnehan told Judge Montgomery, Linnehan besought her to marry him 30 days after she had made his acquaintance. She was clerk and he a driver for the L.A. Smith grocery, 403 E. Lake street. She said Linnehan introduced her to his mother, Mrs. L.A. Glaser, and at once the two began bringing pressure on her to become his bride.

Mrs. Glaser told her, she testified, that Linnehan would join the navy if she did not marry him. Pitying the mother, she finally consented to the marriage, she said. No date was fixed. She said Mrs. Glaser controlled her actions by hypnotic influence.

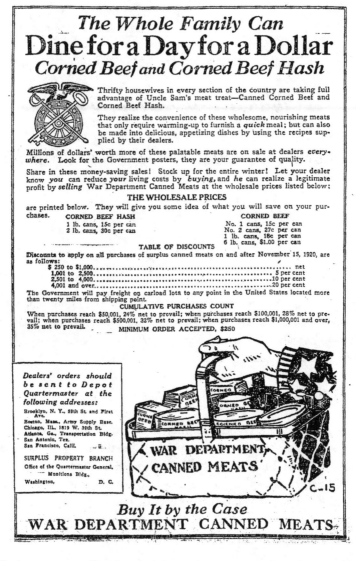

Talk about a mystery. How long had the surplus meats touted in this 1921 ad been in storage at the Department of War? And what, exactly, was in the cans besides meat? *From* Tribune *microfilm.*

One day, she said, Linnehan telephoned her to come over to the home of his mother. When she arrived there, she testified, Linnehan and his mother took her by the arm and escorted her to the courthouse, where a license was obtained and the ceremony performed.

137-Year-Old Indian Dies

FEBRUARY 8, 1922, *MINNEAPOLIS MORNING TRIBUNE*

Ga-Be-Nah-Gewn-Wonce (variously known as Kay-bah-nung-we-way, Sloughing Flesh, Wrinkled Meat or plain old—well, really old—John Smith) was reputed to be 137 years old when he died. Whatever his precise age, his well-lined face indicates a man who led a long and full life. He had eight wives but no children. He fought, he fished, he counseled, he rode horses and trains, he appeared in moving pictures and he sold postcards. The Tribune's page-one obituary featured a two-column photo of Ga-Be-Nah-Gewn-Wonce:

137-Year-Old Chippewa Indian Dies in North Minnesota Home
Oldest Man in Country Was Active Until Week Before Death.

Cass Lake, Minn., Feb. 6—Ga-Be-Nah-Gewn-Wonce, also known as John Smith, a Chippewa Indian reputed to be 137 years old, died here today after a week's illness with pneumonia.

Smith, whose Indian name means "Wrinkled meat," had been very active in late years. A year ago he became totally blind, but his mind remained clear to the last, and he often recalled the days when he was a scout for the Chippewas in the wars with the Sioux. He also remembered events of the war of 1812. One of his boasts was that he had never fought against the white man.

Up to four years ago he had never visited a big city. His first trip of this kind was to the Twin Cities. Later he visited the Automobile show at Chicago.

A year and a half ago he returned to the north woods of Minnesota to spend his time fishing for sturgeon in Lake of the Woods, in the same waters that he fished more than a century ago.

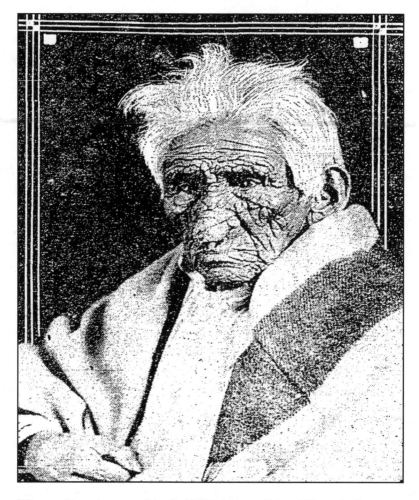

Whatever his age or name, John Smith clearly earned his wrinkles, as well as a prominent place on the front page of the *Tribune*.

Ga-Be-Nah-Gewn-Wonce had been married eight times. He had no children and the only survivor is Tom Smith, an adopted son at whose home he died.

The "old Indian," as he was generally known among the white people, was active until six months ago, since which time he had not been seen outside his adopted son's house. Before that time he had made it a practice to meet all trains entering the village and offer postal cards for sale.

He claimed to have met the Schoolcraft and Cass exploration party which passed through here about 100 years ago, and recalled the changing of the

name of the lake, then known as Red Cedar Lake, to Cass Lake, in honor of one of the leaders of the expeditions.

Two years ago he took the central part in moving pictures taken of Indians, called the "Recollections of Ga-be-nah-gewn-wonce," which have been exhibited all over the United States.

Soon after the prohibition was put into effect, some bootleggers sold "Old Indian" what they claimed to be a quart of whisky, but which proved to be water. "Old Indian" did not say anything, but three years later the same bootleggers purchased a hind quarter of "venison" from him. This turned out to be a portion of an old horse which had just died.

To illustrate his vitality, it is related that seven years ago, when 130 years of age, "Old Indian" was knocked down by a switch engine, while crossing the railroad tracks. His injuries confined him to a hospital for only three weeks after which he suffered no ill effects.

Pagan rites will be omitted at the funeral of John Smith. He will be buried from the Catholic church here, which he joined about eight years ago.

A Tall Order

SEPTEMBER 2, 1924, MINNEAPOLIS DAILY STAR

This likely apocryphal slice of life about a slice of pie deserves a better headline than the one served up by the Daily Star. *Can you top it?*

ONE INDIAN WORD ENOUGH; WAITER LEARNS LANGUAGE

A new waiter came to the White Bus restaurant in Onamia, Minn., today. He was unacquainted with the Chippewa Indian language and was at a loss to understand the strange noises Indians made when they ordered dinner.

John Mah-gua, from the Mille Lacs lake reservation, came into the restaurant with a hunger for pie. When the new waiter heard the order he felt that it was too big for his restaurant to fill.

John asked for Mus-ke-Me-man-Bash-ski-me-ne-se-gan-be-tow-see-chi-gan-Bah-gway-zhe-gan. The new waiter caught his head in his hands and ran out to the kitchen to recuperate.

Then he called up H.D. Ayer at the Mille Lacs Trading Post and tried to repeat what the Indian had said.

"Send the Indian to the telephone, then I'll tell you what it is he wants," said Mr. Ayer.

"John Mah-gua want Musk-ke-ge-Me-man-Bash-ski-me-ne-se-gan-BeTow-see-chi-gan-Bah-gway-zhe-gan," said the Indian.

"Give him a slice of cranberry pie," Mr. Ayer told the waiter, who was on the point of hysterics.

It's unlikely the Chippewa had a word for Jiffy Lemon Pie, a concoction advertised in the *Tribune* in the early 1920s.

After his experience the new waiter declared that he would learn the pronunciation of that word if it killed him.

Here is the explanation: Mus-ke-ge-Me-Man means berry or bog berry; Bash-ski-me-ne-se-gan means jam; Be-tow-see-chi-gan means between two layers, and Bah-gway-zhe-gan means flour, or bog berry jam between two layers of flour.

The Ape-Man of Rose Hill

JANUARY 15, 1925, MINNEAPOLIS DAILY STAR

In the Roaring Twenties, newspapers such as the Star *weren't above giving criminals hysteria-inducing nicknames. Meet the "Ape-Man of Rose Hill," who terrorized the darkened back streets and paths of what is now known as Lauderdale.*

APE-MAN TERRORIZES SUBURB
BRUTE LEAPS FROM TREES AND SEIZES LONE WOMEN.
THREE VICTIMS GIVE DESCRIPTION OF WEIRD-LOOKING ASSAILANT.
RAMSEY, HENNEPIN, ANOKA SHERIFFS WORK ON MYSTERY CASE.

Rose Hill, commuters' settlement of the north city limits at the Hennepin-Ramsey county border, is reaching a climax today of a three weeks' reign of terror.

Men are going armed. Women are afraid to go outside their homes except in daylight—because of an ape-man, leaping from lower branches of trees to attack lone women at night.

He is known to have attacked at least six women since Jan. 1, terrified residents there revealed today. Names of the three were learned by the Daily Star today. Victims describe him as a grotesque figure, more like a half-dressed gorilla than a human being, a silent nightmare.

One 19-year-old girl told today of an attack on her two weeks ago.

She had a premonition as she walked from the carline through the paths between scrub oaks toward her home on Q street; like the others in the village her work requires her to go and come in darkness at this time of year. She had to pass under a tree.

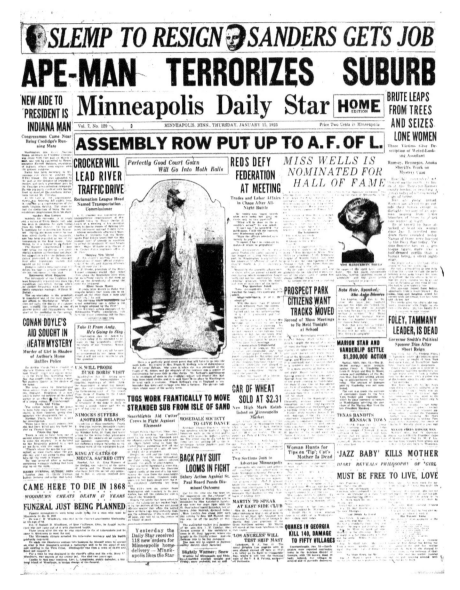

The front page of the *Minneapolis Daily Star* for January 15, 1925, displayed more than two dozen stories and a promotional box announcing that the paper had received 118 new orders for home delivery the previous day.

The ape-man leaped from behind, apparently from a lower branch. His arms, long and dangling, seized her around neck and breast, bore her down and choked her.

Two weeks after the attack she was nearly hysterical with fright as she retold the story. He was hardly five feet tall, she said, but broad. His rugged overcoat, apparently too small for him, was ripped in back and open in front; apparently its buttons were gone before he found it. His shirt was open to the waist; his chest was hairy. His shoulders bulged under the misfit coat. His brown cap did not fit; hair straggled out from under it. He spoke no word, rumbling and growling in his throat like an animal. His face was unshaven, hairy, hideous.

DESCRIBES ASSAILANT.
This was the description she gave today, two weeks later. It will be as vivid in her memory 20 years from now, she said.

Another woman told of being attacked, but she screamed, she said, and someone came running. The ape-man fled. Men of the village tried to track him but failed. The first girl had been choked and unable to scream; the second woman was lucky.

Frank Gibbs, Rose Hill justice of the peace, admitted today that he knew of three women there who had been attacked since Jan. 1.

Ramsey, Hennepin and Anoka county sheriff's offices are working on the search; the village is near the junction of the three counties.

VIGILANTES IN SEARCH.
Besides the deputies, armed vigilantes have been searching nightly, with everything from revolvers to shotguns. Full moonlight the past few nights, they say, has caused the ape-man to stay in hiding, but they are taking no chances on his staying there. The first series of attacks, earlier in the month, was during the moonless part of the month; another period of dark nights is beginning. And except for a few scattered electric lights at prominent corners, the only light in the village at night is from house windows and the scattering automobiles which pass by on the Larpenteur avenue pavement north of the state fair grounds.

NEW SEARCH PLANNED.
At the main corner of the village two corners are occupied by stores; on a third is the beginning of a big nursery tract, with hedges on two sides close to the pavement; the fourth is vacant. Hardly a city block from the main corner, along E. Hennepin avenue toward Minneapolis, is the bridge where

a fleeing man may plunge down the bank to railroad tracks; in that direction the pavement is bordered on both sides by vacant woodland. The roads have been the scene of several holdups of stalled motorists and petting parties.

All this adds to the terror of Rose Hill women—so great that one Minneapolis man admitted today that his young woman friend there was now afraid, even in his company, to walk the short distance from her home to the Como carline after dark.

Another search is planned for today.

The next day, a page-one photo showed one of the trees used by the "ape-man" to launch an attack. The caption described the tree's location: "It overhangs a short-cut path, where a road was once graded through and abandoned, which cuts across blocks from Como avenue and Thirty-third street S.E., crossing the city limits and opening at the north end into Larpenteur avenue, a half-block from the main corner of Rose Hill."

On Saturday, the Star *published a short item noting that St. Paul police had released a Minneapolis youth arrested in the case. Then, on Monday, the "ape-man" acquired a new name, the "ape-man moron":*

POLICE SEARCH FOILS APE-MAN
MORON FRIGHTENED OUT OF ROSE HILL DISTRICT—HUNT CONTINUED.

With but one suspect so far arrested—and released—and with nightly police searches failing to find further trace of the ape-man moron, developments in Rose Hill, terrorized this month by attacks on women pedestrians, were at a standstill today.

Indications were that details of the situation, revealed exclusively by the Daily Star, had accomplished at least two things:

Brought increased police protection, and

Frightened the moron out of the district.

That he had left was indicated by the fact that when last seen, Thursday night, by a woman whom he apparently planned to attack, he was in North Minneapolis. Meanwhile, however, Rose Hill was just beginning to realize its own situation.

Victims of attacks had been loath to report them; it was learned that in most cases the stories had been kept secret. As late as last week, M.V. Frederickson, Ramsey county deputy sheriff who lives at Rose Hill, said he knew of only a very few attacks.

Yesterday Mr. Frederickson told a reporter that he was beginning to receive reports of cases running as far back as two years.

Rose Hill—now Lauderdale—was largely a rural area of small farms and oak woods when this photo of Esther Rasmussen; her younger sister, Helen; and two nephews was taken in the early 1920s. *Courtesy of the Helen Lindstrom family.*

Finally, on the following Saturday, January 31, came a report of another violent attack…and an arrest:

SUSPECT IS HELD AS APE-MAN OF ROSE HILL REGION
PRISONER IS SAID TO HAVE CONFESSED ATTACK ON ST. PAUL WOMAN.

The Rose Hill ape-man was believed to be in jail in St. Paul today.

He had confessed to one brutal attack on a woman, police announced, and Chief Ed Murnane said he hoped to link him with the whole series of Rose Hill attacks which terrorized the suburb north of St. Anthony Park last month.

He is Richard Hebert, 24 years old, 1925 Hyacinth street, St. Paul. The woman involved in his alleged confession was thought to be dying yesterday and her condition today was still critical.

VICTIM FOUND UNCONSCIOUS.

She was found unconscious at 2 a.m. yesterday in an alley at E. Seventh and Mendota streets, by police answering an emergency call from operators at

the adjoining Tower telephone exchange. They had heard a woman scream in the alley. She was revived at Ancker hospital long enough to describe a youth who had followed her from a street car after a dance. A man's cap was found in the alley.

Detectives found the initials R.H. in the cap. Looking through the "H" index in Bertillion records and for the initial "R," they found that five years ago young Hebert had been arrested on an assault charge. They went to his home, learned his parents knew nothing of it, and waited until he arrived at 6 p.m.

He was wearing his father's coat and hat. Taking him to his bedroom they found a blood-stained torn coat, they reported, and with this evidence the alleged confession was obtained.

Hospital physicians were trying today to revive the woman again so that she could identify Hebert. She was unconscious from a fractured skull and concussion of the brain. Meanwhile Rose Hill women, victims of attacks, and street car employes were being called in also to see him.

David Rampaugh and E. Simmons, St. Paul street car employes, told police that a drunken man staggered off the same car from which the woman had alighted, at the same corner. Other streetcar men, it was learned, later saw a hatless man board a Hazel Park car in the same district.

ANSWERS VICTIM'S DESCRIPTION.
Hebert's age and build, police pointed out, corresponded with descriptions given by Rose Hill women, victims of attacks.

His only explanation, according to the police today, of the attack made early yesterday, was: "I was drunk."

FOLLOW-UP: I pored over the next twenty issues of the Minneapolis Daily Star *and found no update whatsoever—no story, no brief, no photo—on this case. What happened to the unconscious victim at Ancker Hospital? Was the suspect ever charged? What did he look like? The* Daily Star *was silent on all these points, apparently for good reason. According to* The Place Most Like Home, *a history of Lauderdale published in 2000, the newspaper's exclusive story was soon revealed to be a hoax, a conclusion sparked by a photo of the Ape-Man's tree that proved to be fraudulent.*

Nearly ninety years later, it's unclear who was behind the hoax. The Ape-Man himself was no doubt fiction, but the newspaper-fueled hysteria surrounding the attacks must have been all too real for the women of Rose Hill.

Baby on (Running) Board

AUGUST 7, 1926, MINNEAPOLIS MORNING TRIBUNE

T ribune *editors smartly chose to display this sweet drama on page one. In 2005, I tracked down the little wanderer, then eighty years old, at his daughter's home in Stillwater. An interview follows the story.*

BABY SLEEPS ON RUNNING BOARD IN 2-MILE RUNAWAY
17-MONTHS-OLD WANDERER, HOME AGAIN, LAUGHS OFF PERIL WITH BLINK.

A 17-months-old boy, far too young to know the trouble he had caused, "ran away" from home Friday afternoon and covered more than two miles of city streets, across town, before he was found. Then he rewarded his parents with a sleepy blinking of his eyes.

The baby boy is Vernon Solem, son of Mr. and Mrs. Emil Solem, 604 Monroe street northeast.

He was playing in the front yard at 4 p.m. Friday. At 4:05 p.m. he had disappeared. His mother, unable to find him, enlisted the aid of the police department, and a futile but thorough search of the neighborhood was begun.

Three-quarters of an hour later a man stopped a motorist at Tenth avenue and Fourth street south, and asked him what he had on the running board of his car.

"Ain't nothing of mine there," the driver answered.

Nevertheless there was something—a sleeping child stretched precariously on the narrow running board. The pedestrian, not concerning himself with the identity of the driver, gallantly offered to take care of the child. He got the job.

$825 COUPE or SEDAN
BODIES BY FISHER

Last January—A New Name
Next January—1,000 Cars A Day

KREMER MOTOR COMPANY
1818 Hennepin Avenue Main 3760

PONTIAC SIX
CHIEF OF THE SIXES

The new 1926 Pontiacs, available at fine dealerships around the Twin Cities, featured dandy running boards. But Vernon Solem said that the car that carried him far from home was likely a Ford. *From Tribune* microfilm.

He carried the child to the Riverside police station, deposited it on a desk and was himself allowed to walk off with the charming anonymity of all heroes. Later the child was taken to police headquarters, where he was identified as Vernon by the Solems.

Violet, 3-year-old sister of Vernon, had the only definite information concerning the disappearance. She saw an automobile parked outside in the front of the Solem home shortly before her brother disappeared.

FOLLOW-UP: Vernon Solem, now eighty-eight, lives in a group home in Woodbury. His daughter, Lynn Kobernat, says that he's "doing pretty good." He has a little dementia, she notes, but is very happy there.

He was quite sharp when I interviewed him in 2005. He did not remember his two-mile ride on the running board—he was only seventeen months old at the time—but he recalled what his mother told him about it years later: "The only thing I was told was that my hands were black from holding on to the fender. It was an old car. I don't know what kind...They thought I was sleeping. I don't know. This all happened on Monroe Street. I think the guy was probably in getting a haircut in the barbershop right there. They parked on the street. He took off driving. It might have been a Model T—they had a running board on both sides. I must have gone on there and laid down or some darn thing."

Solem, one of eleven children, said that the incident didn't have a big impact on how he was raised or on how he raised his four children. But he observed, "I was always protective of myself. Maybe I am different. I'll tell you, I did things different when I was thirteen years old. My friends wanted to get me to smoke, but I tried one and it tasted [awful], so I threw it away and never smoked. I do drink a bit, but not much."

Solem drove trucks for a living, delivery trucks and semis, in the Twin Cities—never over the road. He retired at age sixty-two. He owns a lake home near Alexandria, where he still fishes for "sunfish, walleye, what have you" on occasion.

He was married for fifty-six years. His wife, Evelyn, died in 2003. He moved to an assisted-living apartment in 2005. Had a cancer scare a few years before that.

"I've been pretty lucky in life," he told me. "I've had forty-two treatments for cancer, and that's all over. The doctor told me, 'You're cured.' Like I say, I'm lucky I'm still alive."

U Girls Have Longer Arms

MARCH 2, 1935, MINNEAPOLIS STAR

When critics of MSM (mainstream media) write wistfully of how great American newspapers once were, they aren't referring to the Minneapolis Star *of 1935. This one-source brief leaves many unanswered questions: How many students were measured? Over what time period? How dramatic was the increase? Why weren't men measured? Who paid for this "study," and how much did it cost?*

And just who was the man behind this study? Dr. Albert Jenks, the founder of the University of Minnesota's Anthropology Department, was an influential scholar in his time. A University of Minnesota profile describes him as "a seminal force in the establishment of a systematic, state-wide, cultural-historical approach to the state's archaeological record, an approach that is still dominant in the state today." In 1931, he identified the skeletal remains of the "Minnesota Woman," a girl of fifteen or sixteen whose bones are thought to be eight thousand years old.

But Albert Jenks had some curious theories about race and society. The self-taught archaeologist's papers and speeches were peppered with racist observations. For example, in an address at the Minneapolis Know-Your-City Club in 1912, he said, "Americans could not get a better class of foreigners than the non-criminal Jews." And he listed the Irishman's greatest gift to American culture as his ability to see "the silver lining."

UNIVERSITY GIRLS HAVE LONGER ARMS

Co-eds with short arms are disappearing from the campus of the University of Minnesota, Dr. A.E. Jenks, university anthropologist, has discovered to back his contention that a distinctive American race is being developed.

Albert Jenks, founder of the University of Minnesota's Anthropology Department, knew his way around skeletal remains.

Unless unforeseen immigration of large numbers of definite types into this country takes place, the racial stocks and environment will produce a race which will be taller than average, dark-haired, dark-eyed and darker-skinned than the present typical Minnesotan, according to Dr. Jenks.

Extreme blonds will disappear soon unless there is heavy immigration from northern Europe. Even the pure Negro stock in this country is being lost, he declared.

New Runestone Found

AUGUST 7, 1949, MINNEAPOLIS SUNDAY TRIBUNE

*A*ny Minnesotan worth his lutefisk is familiar with the Kensington Runestone, the 200-pound slab of rock that turned up near a settlement of that name in 1898. The message carved into the slab was purported to prove that Scandinavian explorers reached the middle of the state in the fourteenth century, but virtually all experts consider it a fraud. At least two other carving-laden slabs were found in Minnesota. In 1915, workers digging a well at a home on South Forty-eighth Street near Minnehaha Falls found a 250-pound stone slab on which were chiseled a crown, a castle and a lion, "similar to those worn on the shields of early British and French explorers." Experts immediately pronounced it a likely fraud. Thirty-four years later, another runestone was "discovered" in west-central Minnesota, just nine miles from where the Kensington Runestone was found. Again the experts were dubious. That didn't stop Tribune editors from putting the story on page one.

New Runestone Found in State

By Ed Crane
Minneapolis Tribune Staff Writer

ELBOW LAKE, MINN.—A new runestone has been found in Minnesota, but its authenticity was disputed Saturday.

Small enough to be lifted by one man, it was discovered on a farm nine air miles northwest of the spot where the famed Kensington runestone was found nestled in the roots of a tree in 1898.

Scratched on the surface of the heart-shaped object are some 34 characters which appear to resemble the ancient Scandinavia alphabet known as "runes."

"LOVERS' LANE."

J.A. Holvik, Norwegian professor at Concordia college, a skeptic regarding the Kensington runestone, said he translated the new stone's message and expressed doubt it is genuine.

Holvik said it reads: "Year 1776. Four maidens set camp on this hill."

The place where the new discovery was made is known as Maiden Hill, a traditional "lovers' lane" for young folk of the vicinity.

The Kensington runestone, if authentic, tells the story of "8 Swedes and 22 Norwegians" who wandered up the Red river nearly to Alexandria in 1362.

But 1776 is a familiar historic date, and by that time a number of nationalities had hit the shores of America. Runic characters by then had been out of use for centuries.

PLANS PICNIC GROUNDS.

The story of the new discovery to date offers a strange parallel to that of the earlier find. Victor Setterlund, a farmer living about three miles northeast of Barrett, Minn., said he found the heart-shape stone five years ago as he was digging a foot path along the hill.

The Setterlund farm is seven miles southeast of Elbow Lake.

Of late Setterlund has been preparing the land in the discovery area for a new picnic grounds.

Last Wednesday, Ansel Sletten, an Elbow Lake automobile dealer, was at the Setterlund farm, to sell the farmer a new car.

Setterlund showed Sletten his discovery and said: "You're a pretty smart fellow. Maybe you can tell me what this is."

Sletten said he tried to buy it from Setterlund, but failed. He did succeed, however, in borrowing the stone to take it to Elbow Lake.

Warren Gahlon, editor of the Elbow Lake Herald, took a look at the stone and offered $100 for it, but still no sale.

Sletten, until the translation was made, wanted the discovery listed as being seven miles southeast of Elbow Lake. After the translation, he decided three miles northeast of Barrett was all right.

It still remained a mystery yesterday as to whether the discovery is a hoax, as a number of people stoutly maintain the Kensington stone is.

Douglas county historian R.S. Thornton, Alexandria attorney who was closely associated with the studies of the Kensington stone, did look at the new find.

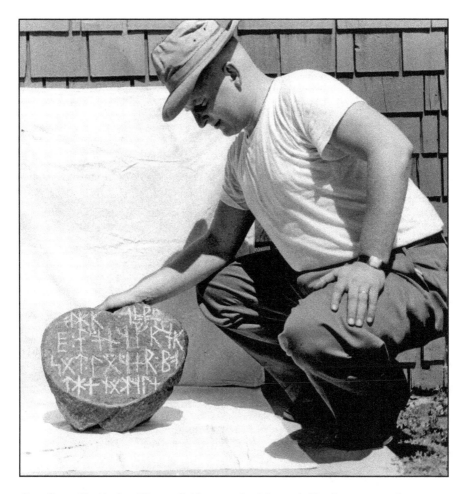

Grant County Herald editor Warren Gahlon examined the runic-like characters on the stone found near Elbow Lake, Minnesota. *From the* Minneapolis Tribune.

He said yesterday he thinks the characters on the stone are similar to those on the Kensington runestone. He translated part of the inscriptions as a reference to making camp, but added that he may have misread it.

Thornton said he doubts that the new stone and the Kensington discovery were chiseled by the same person.

Through out this period the authenticity of the Kensington stone was debated in newspapers. It was the subject of magazine articles and a civic festival at Alexandria. Nevertheless, Setterlund said neither he nor his friends thought the find important enough to investigate.

The new stone is of glacial granite and weighs about 75 pounds. Characters on it are about two inches high.

Hjalmar Holand of Ephraim, Wis., expected to visit Elbow Lake soon. Holand first investigated and later defended the Kensington stone. His efforts were rewarded last year when it went on display at the Smithsonian Institution in Washington.

FOLLOW-UP: Holand visited Elbow Lake shortly thereafter and, sure enough, declared the stone a fraud. Setterlund soon confessed to carving the runes. The heart-shaped rock, now known as the Victor Setterlund Runestone, is on display in the Grant County Museum in Elbow Lake, accompanied by a sign that acknowledges its true origins.

Muskie Fever

JULY 20, 1955, MINNEAPOLIS STAR

*A*n angler's dream unfolded one hot weekend in July 1955. Huge muskies began hitting "anything and everything" in the northeast corner of Leech Lake, a 175-square-mile reservoir in north-central Minnesota. Before a storm blew in a few days later and ended the run, anglers swarmed the headwaters of the Leech Lake River and landed more than one hundred trophy muskies. What prompted the great fish to go on a feeding frenzy unmatched in state history? More than fifty years later, the cause is still unknown.

FANTASTIC MUSKY MOB SCENE PANICS LEECH

By JACK CONNOR
Minneapolis Star Outdoor Writer

This is a fantastic story about that fantastic fish—the muskellunge.

Only those who have seen or caught the evidence can believe it.

The little town of Federal Dam, Minn., where Leech Lake river empties into Leech lake, is wild with excitement.

Since Saturday, huge muskies from 15 to 43 pounds have been on a rampage. No one can explain why—not even state fisheries bureau biologists.

The action started, quite by accident, Friday afternoon. From then until noon Tuesday a total of 83 big muskies have been landed.

They were hitting anything and everything.

And they were in an area of the lake where no one thought there were muskies before. At least none had been caught there in years.

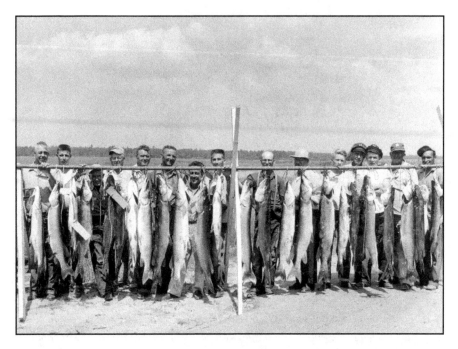

It was like shooting fish—mighty big fish—in a barrel. *From the* Grand Rapids Herald-Review.

The area is five miles south and west of the five boat landings at Federal Dam among a field of bulrushes in 15 feet of water.

Today proprietors of the five boat landings were booked solid for the rest of the week and into next week. Launches were converging on the area from all parts of expansive Leech Lake.

The fantastic story goes back to last Friday afternoon when Mr. and Mrs. Al Storer went out fishing walleyes on nearby Boy river. Mrs. Storer had a minnow and spinner walleye hookup. But a muskie estimated at 25 pounds took it. She lost the fish when it got near the boat.

That evening they drove over to Merle Wescott's landing below Federal Dam on Leech Lake. They were fishing for walleyes again. But they got two muskies instead.

Next day, Saturday, they were back on Leech with Morris Cohen and Art Green, both of Chicago. The four of them got nine more muskies. Westcott, his son, father and a cousin also were out. They got five.

That started the muskie rush. The word passed like a prairie fire out of control.

"It was like a dream," Mrs. Storer said today. "You could see those big muskies lying right on top of the water.

"There were boats everywhere and in every one somebody was landing a big muskie or playing one at the end of his line. They were leaping all over the place."

From Saturday until yesterday 20 big muskies were brought into Neurer's landing. The largest weighed 42 pounds, 6 ounces, and was caught by Walter Kreutner of Shellsbury, Iowa.

That one set a new season record for this or any other state.

Twenty-four more big ones were brought into Stillman's landing, 20 into Wescott's landing, seven into Warren's landing and 11 into Bader's landing.

The best at Wescott's weighed 39 pounds and was caught by Walter Foster, Harvey, Ill. George Durkee, a Federal Dam guide, brought a 38½-pounder into Bader's. Rusty Lego, another guide, came into Stillman's with a 37-pounder.

Warren Bridge of Warren's landing brought a small one in, only 24½ pounds.

Dick Spadafore, Deer River editor, checked all landings today. "You couldn't get a boat. But there's a public landing at Sunset bay on Leech lake.

"I don't know how long this will last, but it's been a merry-go-round since it started. No one knows what caused it. Even the guides have no idea."

The D.B. Cooper Hijacking

NOVEMBER 27, 1971, MINNEAPOLIS TRIBUNE

The unsolved hijacking of Northwest Flight 305 on Thanksgiving eve 1971 spawned scores of books, TV shows, movies and songs. Here's the Tribune's *page 1A account of the press conference held at the Minneapolis–St. Paul International Airport two days after the well-mannered hijacker jumped off the jet's rear stairway, presumably wearing a parachute and carrying a bag holding $200,000 in cash. The story doesn't mention "Dan Cooper," the name the hijacker used that night.*

HIJACKER'S NOTE AT FIRST MISTAKEN AS DATE INVITATION

By DEAN REBUFFONI
Staff Writer

A Northwest Airlines stewardess said Friday she first thought a note handed her by a hijacker on a flight Wednesday between Portland, Ore., and Seattle, Wash., was "a pass" or an attempt to "hustle" her.

Stewardess Florence Schaffner, 23, who said she regularly encounters amorous passengers in her work, put the note in her purse without reading it.

The hijacker, who was sitting beside her for the takeoff, motioned to her to read the note, however. It was then that Miss Schaffner, 1600 E. 77th St., Richfield, discovered that the man claimed he had a bomb, was demanding $200,000 ransom, four parachutes and the flight crew's cooperation in his escape.

The hijacker—described by crew members as "not nervous," "rather nice," and "never cruel or nasty"—got everything he wanted, and apparently

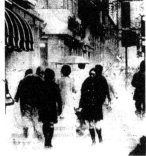

The *Minneapolis Tribune* front page of November 27, 1971, trumpeted a scoop by veteran sports columnist Sid Hartman: Murray Warmath was on his way out as the University of Minnesota's football coach.

Left: After the plane left Seattle, the hijacker told flight attendant Tina Mucklow to "go to the front, pull the curtain and don't come back." *From the* Minneapolis Tribune.

Right: Captain William Scott said that he found the passenger cabins empty when he walked back from the cockpit after landing in Reno. *From the* Minneapolis Tribune.

used two of the parachutes to leave the Boeing 727 jet airplane sometime during its flight later Wednesday from Seattle to Reno, Nev.

At a press conference yesterday morning at the Minneapolis–St. Paul International Airport, the plane's six crew members gave this account of the hijacking:

The middle-aged hijacker, who wore dark glasses, a dark overcoat and a business suit, apparently boarded the plane, Northwest's flight 305, in Portland. He sat alone in the last row of seats in the coach compartment.

Shortly after takeoff from Portland, the man asked Miss Schaffner to sit beside him and then handed her the note.

After she read the note, Miss Schaffner looked inside a small black suitcase the man was holding.

"I was scared to death and pretty nervous," she said "but I do remember seeing a red cylinder in the suitcase."

She said the hijacker had no other suitcases with him, and added that the cylinder filled the black suitcase.

While Miss Schaffner carried the note forward to the plane's cockpit, a second stewardess, Tina Mucklow, 22, sat next to the hijacker to, as Miss Mucklow said, "ensure our passengers' safety."

The plane's commander, Capt. William Scott, 262 Peninsula Rd., Medicine Lake, read the note and contacted Northwest officials via radio. He was told the money and parachutes would be delivered to the airplane while it refueled in Seattle.

Scott went into a holding pattern northwest of Seattle while the $200,000 was collected from several Seattle banks and the four parachutes from nearby McChord Air Force Base.

The airplane landed after about one hour and 40 minutes of circling. The plane's 36 other passengers—who were not aware of the hijacking—left the aircraft in Seattle with Miss Schaffner and a third stewardess, Mrs. Alice Hancock, 24, Inver Grove Heights.

Scott, First Officer William Rataczak, 3407 Selkirk Dr., Burnsville, and Second Officer Harold E. Anderson, Excelsior, remained in the cockpit throughout the hijacking. They never saw the hijacker.

Miss Mucklow, 7320 Cedar Av., Richfield, remained seated beside the hijacker in the coach compartment and relayed his demands to the cockpit via the plane's intercom system.

"He was always polite to me," Miss Mucklow said of the hijacker. "He did seem impatient at times, though."

While the plane was being refueled, a courier delivered the $200,000—in $20 bills—and the four parachutes. Miss Mucklow met the courier at the foot of the aircraft's stairs. The money, she said, was in a "soft, white, cloth laundry bag." She said the bag was open and had no drawstrings.

Scott said the hijacker demanded the airplane fly to Mexico City, but the captain emphasized that the man did not demand the plane fly a certain route.

"All he knew was he was being taken to Reno (for refueling) on the first leg of a flight to Mexico," Scott said.

The hijacker also demanded the crew open the plane's rear door and lower the stairwell after takeoff from Seattle. Scott said he flew below 10,000 feet altitude and at about 200 miles per hour during the Seattle-Reno flight.

Scott said he and his crew made no attempt to stop the hijacking, but followed the orders of Northwest officials with whom they were in radio contact.

"Everything seemed to go nicely as long as we went along with (the hijacker's) demands," Scott said. He added that there was no sky marshal on board the plane at any time.

Miss Mucklow remained with the hijacker as the plane left Seattle. Shortly after takeoff and about 8 p.m. Wednesday, Scott lowered the plane's rear stairs. The hijacker then told Miss Mucklow to, she said, "go to the front, pull the curtain (between the coach and first-class compartments), and don't come back."

Above: An FBI sketch of the hijacker with sunglasses and without.

Left: Remember the Embers? In its heyday, the regional restaurant chain advertised regularly in the *Minneapolis Tribune*, touting specials like this one the week of the hijacking. On the same page, the *Tribune* plugged an upcoming investigative series in the *Star*: "What's in the hamburger you buy?" *From* Tribune *microfilm*.

Miss Mucklow did just that. There was no further communication with the hijacker during the Seattle-Reno flight.

Scott said he assumed the hijacker was still aboard when the plane landed in Reno. He denied reports that he had radioed officials as the plane approached Reno that the hijacker "took leave of us."

November 28, 1971: the *Tribune*'s readership evidently included a sizable number of wig buyers. *From* Tribune *microfilm.*

After landing in Reno, Scott tried to call the hijacker on the plane's public address system. He addressed the man as "Sir," and asked if the hijacker had further instructions.

There was no reply. Scott said he found the passenger cabins empty when he walked back from the cockpit after landing.

Two of the four parachutes were still in the plane, Scott said. There was no trace of the hijacker, the money, the laundry bag or the black suitcase the hijacker claimed held a bomb.

FOLLOW-UP: Over the next several months, investigators searched larges areas of mountain wilderness in southwestern Washington, the area where Cooper most likely would have landed on that rainy night, and found no evidence related to the case. Some of the ransom money turned up in 1980 on the banks of the Columbia River, nine miles downstream from Vancouver, Washington. None of the remaining cash has surfaced anywhere in the world.

The FBI has insisted from the start that the hijacker could not have survived the difficult nighttime jump. One of the two parachutes he chose was a nonfunctional training model, suggesting he was anything but an experienced skydiver. Still, the case remains open, and the Bureau continues to publicize new evidence as it becomes available.

About the Author

B en Welter, news copy chief at the *Star Tribune*, is a Minneapolis native and University of Minnesota graduate. He has been reading newspapers since his first-grade teacher, Sister Romana, taught him how to say the alphabet backward and forward in 1965. Forty years later, he began scouring his paper's microfilm in search of interesting stories and photos dating back to 1867. He has posted more than five hundred of the best on his blog, "Yesterday's News" (startribune.com/yesterday). To avoid dating himself, he established one rule at the blog's launch: stories published during his own lengthy newspaper career do not qualify as "Yesterday's News." He has broken that rule just once, posting an account of Twins legend Kirby Puckett's exhausting first day in the Big Leagues in May 1984.

Your comments, memories and suggestions are welcome at www.startribune.com/yesterday. Or follow him on Twitter (@oldnews).

CPSIA information can be obtained
at www.ICGtesting.com
Printed in the USA
LVHW081148040520
654959LV00014B/252